Postcard History Series

Parkersburg
in Vintage Postcards

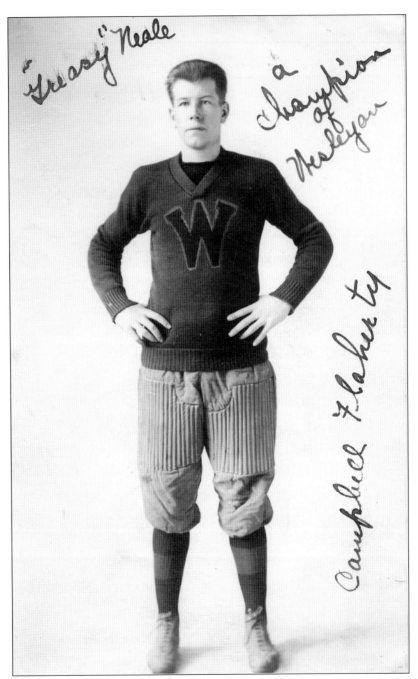

GREASY NEALE. One of Parkersburg's most famous personalities was Alfred Earle "Greasy" Neale. He was born in Parkersburg to William H. and Rena Neale on November 5, 1891. He attended Parkersburg High School from 1909 to 1911 and played football, basketball, and baseball. He enrolled at West Virginia Wesleyan College where he was a star athlete for four years. Greasy was nationally known as the head football coach for the Philadelphia Eagles and was inducted into both the College and Professional Football Halls of Fame. Greasy Neale passed away on November 2, 1973, in Florida.

POSTCARD HISTORY SERIES

Parkersburg
IN VINTAGE POSTCARDS

Christy and Jeff Little

Copyright © 2005 by Christy and Jeff Little
ISBN 978-0-7385-1817-6

Published by Arcadia Publishing
Charleston SC, Chicago IL, Portsmouth NH, San Francisco CA

Printed in the United States of America

Library of Congress Catalog Card Number: 2005922056

For all general information contact Arcadia Publishing at:
Telephone 843-853-2070
Fax 843-853-0044
E-mail sales@arcadiapublishing.com
For customer service and orders:
Toll-Free 1-888-313-2665

Visit us on the Internet at www.arcadiapublishing.com

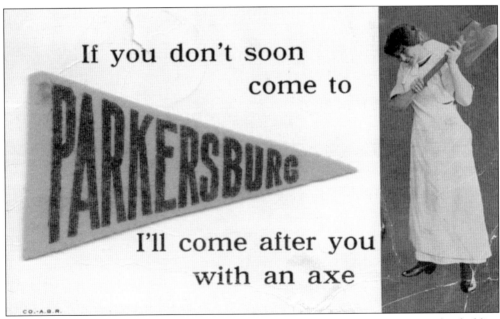

YOU BETTER COME TO PARKERSBURG, C. 1912. Why is this lovely young maiden holding a big, scary axe? She was part of the popular Victorian trend of comical scenarios. This postcard promoting the city of Parkersburg has a pink felt pennant affixed to it. Other clever ideas for souvenir postcards included name personalization, words covered with glitter, postcards made entirely from leather, etc. A large variety of these types of postcards could be purchased from corner drugstores and markets. Today they are very collectible.

Contents

Acknowledgments — 6

Introduction — 7

1. Panoramic Views and Street Scenes — 9
2. Prominent Buildings — 25
3. Storefronts and Business Interiors — 47
4. Hotels, Motels, Tourist Homes, and Flats — 61
5. Disasters — 67
6. Parks and Special Events — 87
7. Churches and Schools — 103
8. Bridges, Boats, and Streetcars — 117

ACKNOWLEDGMENTS

We are grateful to the following individuals and organizations for contributing their postcard images to this book: Dr. John E. Beane; Blennerhassett Island Historical State Park; Wood County Historical and Preservation Society; Bill Miller; Dave McKain of Parkersburg's Oil and Gas Museum; and Paul Borrelli of Artcraft Studio. We also would like to thank Kim Miller of the Antique Automobile Club of America in Hershey, Pennsylvania, for identifying the antique cars shown in this book; Bob Enoch and Dr. Ray Swick for information and proofreading; John King and Dave McKain for information; and Lauren Bobier of Arcadia Publishing, who was a joy to work with throughout this book-making process.

Postcards in this book, unless otherwise designated, are from the authors' collection.

Front cover postcard courtesy of Dr. John E. Beane. Back cover postcard courtesy of Blennerhassett Island Historical State Park.

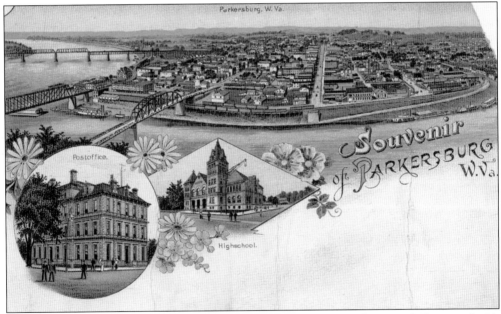

PIONEER POSTCARDS. On a trip to Germany in 1896, a local jeweler named Gustavus Smith ordered a picture postcard depicting Parkersburg High School and the post office. Shortly after, he produced a second card depicting the city block of the Blennerhassett Hotel, G.E. Smith store, and Jackson Hotel. Privately printed cards were illegal at this time in the United States, and Smith was notified to cease selling the cards. Mr. Smith had the phrase "postal card" overprinted with his name and address and gave them away as advertisements. In 1898, these cards were legalized and Mr. Smith produced another of the Parkersburg City Building and the Wood County Court House. (Courtesy of Blennerhassett Island Historical State Park.)

INTRODUCTION

The land at the confluence of the Ohio and Little Kanawha Rivers along Virginia's western border had been occupied by Native Americans since prehistoric times. Later, frontiersmen and fur traders occupied it. The first permanent white settlement was established by a group of pioneers led by Capt. James Neal in the fall of 1785.

The area north of the Little Kanawha River's mouth initially was called "The Point" and, by 1800, "Newport." In 1810, an act was passed that established the town of Parkersburgh, Virginia (now West Virginia), named in honor of Capt. Alexander Parker, one of the original owners of the land. Parker's daughter, Mary Robinson, donated property for the public square in 1811. George D. Avery, a local surveyor, laid out the town.

Parkersburg and the picture postcard came together in 1896 when local businessman Gustavus Edward Smith produced the first of three Parkersburg souvenir postcards.

It was not until 1898 that postal cards were legally recognized by the U.S. Postal Service. Postal regulations specified that only the name and address of the recipient could be placed on the address side of the card. This meant that personal messages had to be written around, under, or on top of the printed image on the front of the card. A change came in 1907 that greatly influenced the postcard industry. The U.S. Postal Service decreed that the address side of the card could be divided down the center. This allowed the right side to be used for a name and address and the left side for personal messages. Thus, the postcard craze began all across the country.

Tens of thousands of beautiful postcards, depicting a seemingly limitless array of pictures and greetings, including hometown views, were now produced and sold inexpensively. Each could be mailed with a penny stamp. Real photo postcards were quick to follow in popularity. Sending and receiving postcards now became a household pastime. Whenever Aunt Bessie or Cousin Harold took to the countryside or seaside, the folks back home eagerly awaited a souvenir postcard recording their loved one's adventures. The personal messages and pretty pictures made postcards treasured keepsakes that families neatly tucked away in special albums or shoeboxes to preserve for the generations to come.

Postcards are attractive and interesting to collect. They often contain images of people and places that may otherwise not have been recorded. Twenty years ago, when we began collecting local images, there were probably fewer than a dozen collectors of Parkersburg postcards. Prices were low and competition was minimal. Today, the collectibility of local memorabilia is at an all-time high, with perspective buyers lining up hours in advance at estate tag sales, trying their luck with on-line auctions, and storming into rummage sales with frenzy.

Postcards can be divided into two basic types, printed and real photo. Printed cards were usually mass-produced. Real photo postcards were normally produced in far smaller quantities. Some were one-of-a-kind creations made by amateur photographers. Many techniques can be used to date a postcard, such as if the card has a divided back or not, reading the postmark, learning about the printer and/or publisher, interpreting the printer's catalog number, the design of the stamp box, or identifying the subject matter.

As dedicated collectors, we are grateful for the survival of the following vintage postcards presented in this book and are happy to share them with you.

—Christy and Jeff Little

PARKERSBURG ON THE MAP, C. 1908. Back when this card was produced, Parkersburg had a population of about 25,000. William Barbour Pedigo, attorney, was the mayor. The city offered 10 banks, 4 city streetcar routes, 20 churches, 15 miles of brick-paved streets, and 3 daily newspapers. The chief industries were woodworking, steel and iron, and oil refineries. There were approximately 200 industrial establishments in town and many fine retail and wholesale dealers.

One

Panoramic Views and Street Scenes

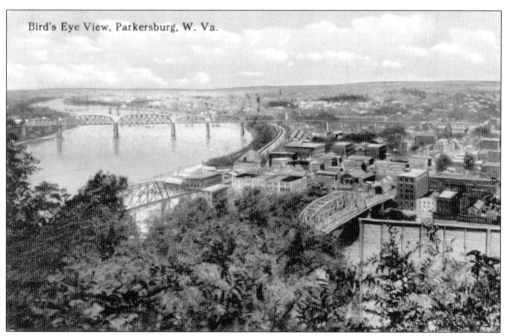

Bird's-Eye View of Parkersburg, c. 1910. This panoramic image of Parkersburg is taken from the elevated site of Fort Boreman Hill. It is a classic view of "the Point"—the confluence of the Ohio and Little Kanawha Rivers. The Baltimore & Ohio River Railroad Bridge over the Ohio River is visible, as well as the Ohio River Railroad Bridge and the Juliana Street Bridge over the Little Kanawha River. The back side of John Taft's dry goods store billboard can be seen on the bottom right of this card.

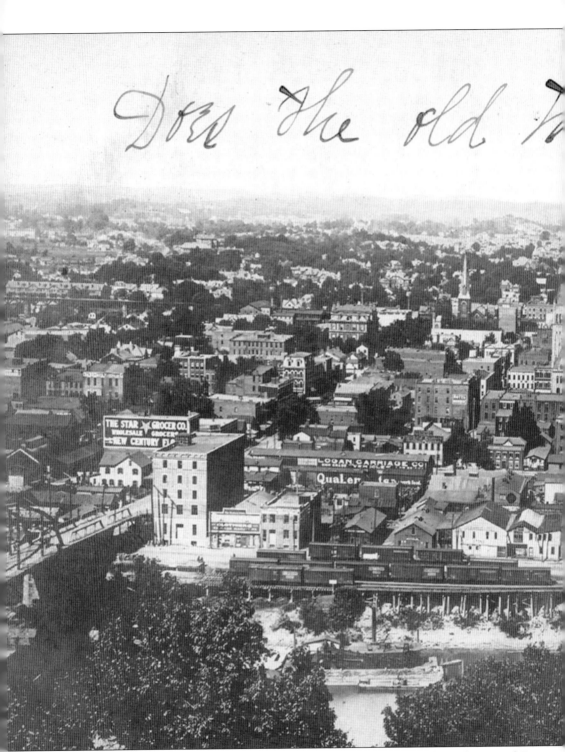

Parkersburg Panorama. Here is Parkersburg, West Virginia, as seen from the top of Fort Boreman Hill. Nearly 100 years ago, the city looked considerably different than it does today. The urban renewal project of the 1970s replaced many older structures with modern buildings. The

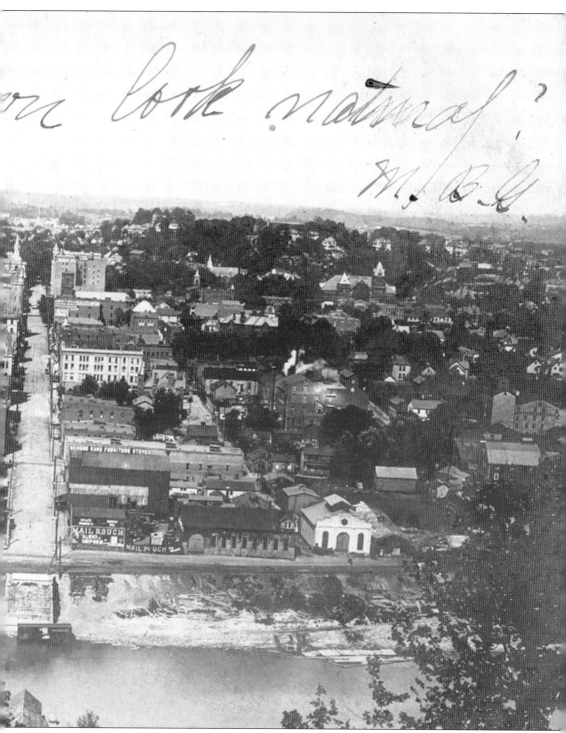

difficulty and expense of maintaining aging structures, the ever-increasing desire for parking lots, and the shifting of most retail stores to the vicinity of the shopping mall have all contributed to the changing look.

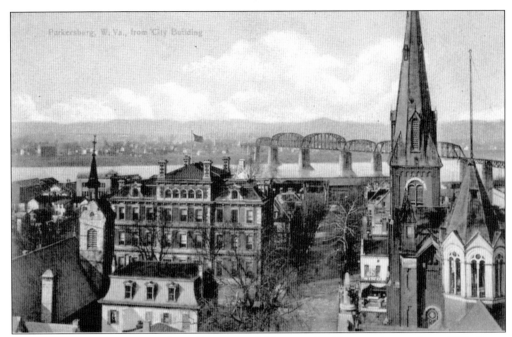

VIEW FROM PARKERSBURG CITY BUILDING. This scene looking northwest down Fifth Street toward the Ohio River was taken from atop the Parkersburg City Building. The top of the Trinity Episcopal Church and the front of the Federal Building on Juliana Street can be seen on the left. The large steeple of the old First Methodist Episcopal Church can be seen on the right.

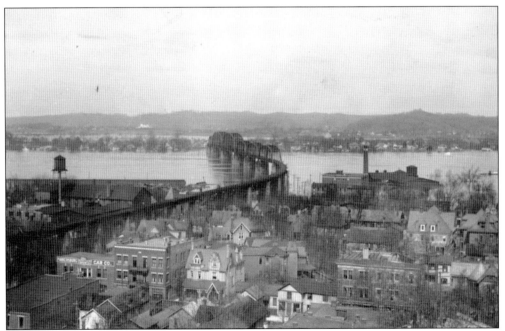

VIEW FROM QUINCY HILL. This bird's-eye view of Parkersburg from the summit of Quincy Hill overlooks the flooded Ohio River in March 1913. The high water against the piers of the Baltimore & Ohio River Railroad Bridge indicates the severity of the flood.

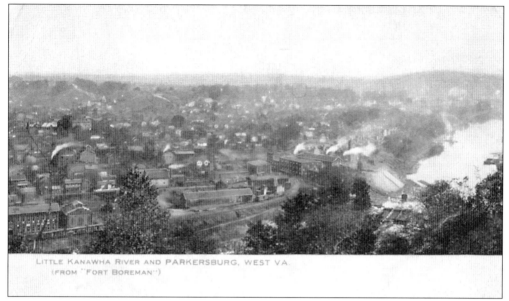

LITTLE KANAWHA RIVER VIEW. This view of Parkersburg from Fort Boreman is slightly unusual in that it focuses on the more industrialized section of the riverfront, along the banks of the Little Kanawha River. It was in this vicinity, on June 1, 1895, that 2,500 pounds of nitroglycerine being transported on a boat from the Pittsburgh area to Burning Springs exploded, causing much damage. The conductor of the boat was blown to bits, and portions of his remains were later located throughout town. Window glass in many downtown buildings was shattered.

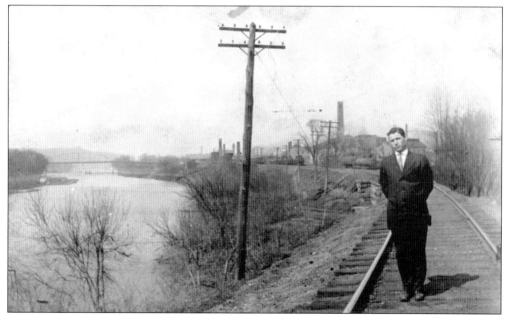

ALONG THE LITTLE KANAWHA. This postcard view is looking west along the Little Kanawha River. The unidentified gentleman is standing on the Baltimore & Ohio Railroad track that ran from Parkersburg to Grafton. The old Standard Oil Refinery can be seen in the background. (Courtesy of Bill Miller.)

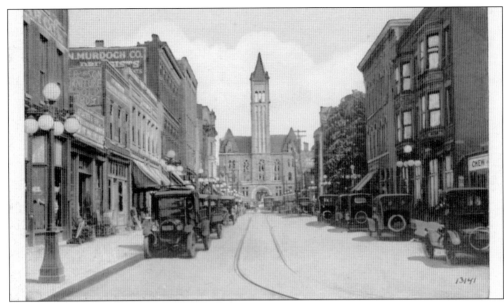

THIRD STREET. This scene taken from the Third and Ann Streets intersection looks down Third toward Court Square and the Wood County Court House. On the left at 101–103 Third Street is Baumberger Motor Car Company, dealers in Hudson and Essex automobiles. Further down the street are several furniture dealers. On the right is Duncan Furniture Company and Logsdon Musical Instruments. Streetcar tracks turned here onto Ann Street, circling these two blocks and then meeting back at Juliana and Third Streets.

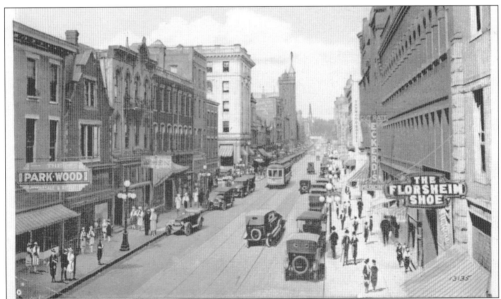

MARKET STREET, NORTH FROM THIRD STREET. On the right is the edge of the Jackson Hotel, followed by the Smith Building and then the Blennerhassett Hotel. On the left are the Park-Wood Shoe Company, Kahn's Men's Furnishing, and other retail establishments. All of the structures in this block on the left were torn down during urban renewal. In the mid-1980s, the Town Square Complex was built on the site.

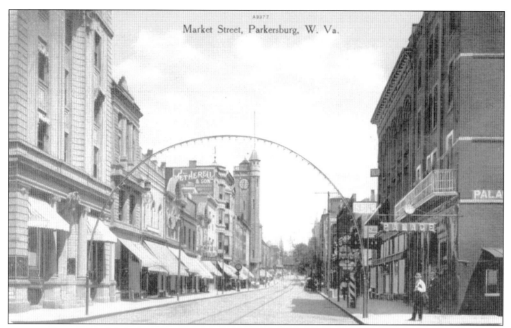

MARKET STREET, NORTH FROM FOURTH STREET, C. 1910. These large electrified arches were placed along Market Street at the intersections of Third, Fourth, Fifth, and Seventh Streets. In this scene, the Citizens' National Bank is on the left and the Palace Hotel is on the right. The Palace Hotel, built as the Hotel DeGraff, was destroyed by fire on the night of December 9, 1945. A disgruntled 35-year-old hotel employee by the name of Shelley Hart started the fire that resulted in seven deaths.

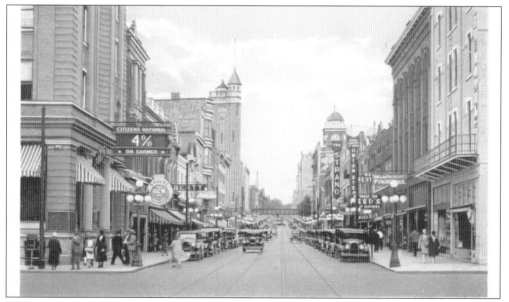

MARKET STREET, NORTH FROM FOURTH STREET, 1931. This view depicts the same street scene as the one above, but 20 years later. Market Street had undergone many changes by 1931. Boulevard lights were placed along the sidewalks in 1912, the street was paved with concrete in 1921, and the large electrified arches were removed.

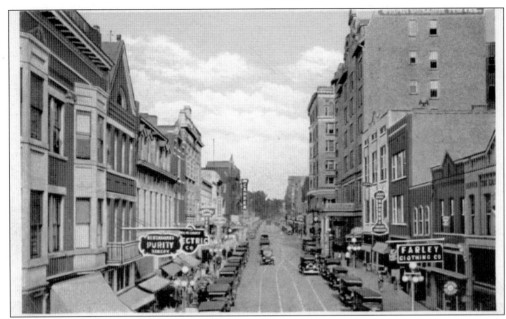

MARKET STREET, NORTH FROM SIXTH STREET, 1930. This photo was taken from atop the Sixth Street Baltimore & Ohio Railroad Bridge looking north. Parkersburg's Market Street offered every modern convenience. On the west side of the street was clothing at Farley's Store, jewelry and china from Roger's Jewelers, and a place to lodge at Chancellor Hotel. On the east side of the street, food and drink were available at Purity Baking and Bottling, electrical needs from McHenry Electric, and entertainment further up the street at the Camden Theater.

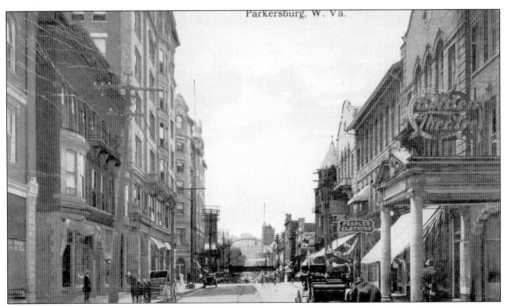

MARKET STREET, 700 BLOCK, C. 1914. On the right side of this view of the 700 block of Market Street is the Camden Theater. It was part of the city block built by Sen. Johnson N. Camden through the Opera Block Investment Company. On the left are the Union Trust Building and the Chancellor Hotel Building.

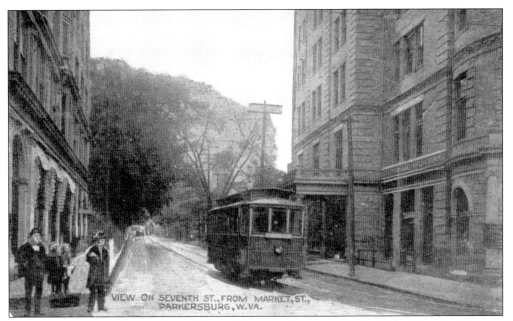

SEVENTH STREET. This artistic rendition of Seventh Street shows the Union Trust building on the left and the Chancellor Hotel on the right. An outer loop Parkersburg, Marietta, & Inter-Urban Railway streetcar is seen between the buildings. Two streetcars were deployed, 15 minutes apart, for the 30-minute route.

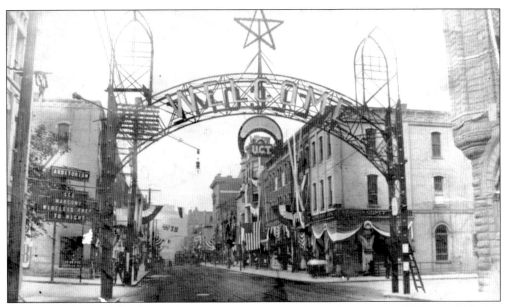

WELCOME ARCH. This impressive structure was erected on the corner of Fifth and Market Streets as a "welcome" to members of the Grand Council of the United Commercial Travelers, who held their convention in Parkersburg in May of 1908. It was constructed of iron, each side column being 45 feet high. Wired with approximately 1,000 electric lights, it was said to resemble a sparkling tiara. It remained a familiar fixture to Market Street for many years until its removal in May 1927. (Courtesy of Blennerhassett Island Historical State Park.)

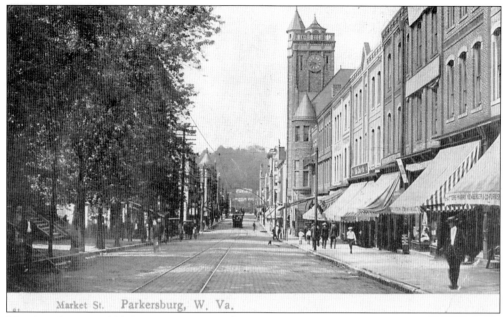

MARKET STREET, 500 BLOCK, C. 1915. This vintage view shows a classic Market Street facade of awning-covered storefronts. Visible in this 500-block scene looking south are Harry Newberger & Co., Brown's Drug Store, the Surprise Store, the Atlantic Tea Co., and Dils Brothers & Co. Across the street behind the shadow of the trees is the St. Francis Xavier Church.

MARKET STREET ABOVE EIGHTH, 1907. This real photo postcard image was taken from the 700 block of Market Street looking north past the Eighth Street intersection. Wetherell's Jewelry Store at 809 Market Street, then the Oeldorf Flats building, can be seen at the left, as well as the First Baptist Church's steeple. The residential homes along the right side of the street have long since been replaced with commercial structures.

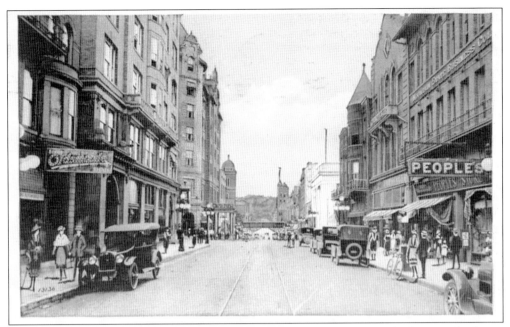

MARKET STREET, C. 1926. This view is of the 700 block of Market Street looking south. Shown on the left is the Parkersburg Automobile Company followed by the Union Trust. The Union Trust building was then a seven-story office building with approximately 50 different business tenants. On the right is the People's Clothing Store and Mountain State Business College.

JULIANA STREET, C. 1906. Druggist William I. Boreman produced a series of 12 different picture postcards featuring Parkersburg buildings and street scenes. This card, number 10 of that series, shows Juliana Street from the Tenth Street intersection looking north toward Eleventh Street. Juliana Street is one of several city streets named after the daughters of Parkersburg's namesake, Alexander Parker.

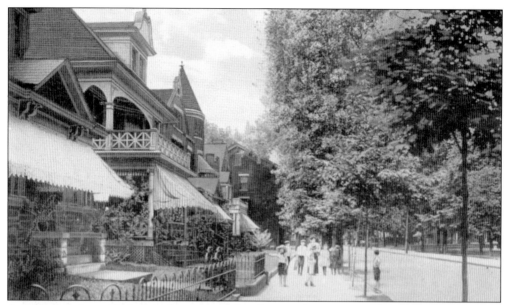

ANN STREET, C. 1910. Ann Street, named in honor of Annie Alexander Parker, daughter of Alexander Parker, contained some of the finest residences in Parkersburg. This street scene is of the 700 block of Ann Street, taken from the southeast corner of Eighth and Ann Streets intersection. The George Case home—noted for its seven magnificent stained-glass windows depicting cupid, Queen Louise, scenes from Shakespeare, and so on—is the first on the left, surrounded by the wrought-iron fence. All of the houses pictured here have been demolished for parking.

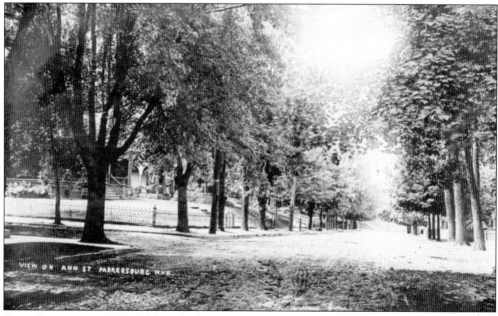

ANN STREET, C. 1906. This real photo postcard shows Ann Street and the intersection of Eleventh Avenue prior to the streets being bricked. In 1977, residents of the Ann and Juliana Streets neighborhood formed Parkersburg's first historic district, Julia-Ann Square, by placing this area on the National Register of Historic Places. Most homes in this area date from 1875 to 1915.

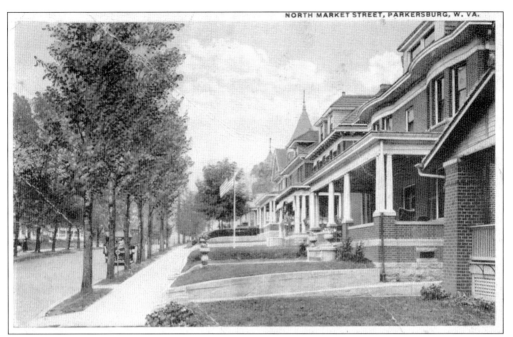

NORTH MARKET STREET, 1916. This view of upper Market Street is taken from the front yard of 1314 Market—then the home of Thomas R. Cowell. The next home, 1316, was owned by John Joseph Crotty, and the following home, 1318, by Fred M. Cochran. This portion of Market Street has remained a residential area.

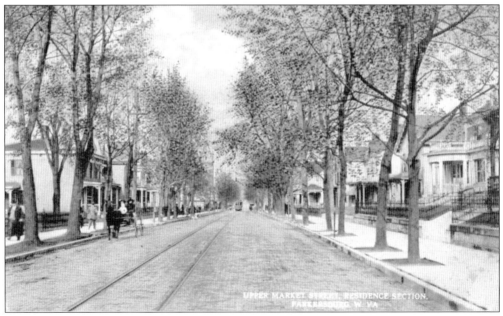

UPPER MARKET STREET, 1914. As Parkersburg's business district grew, residential areas shifted further away from the downtown area. This postcard, labeled as a residential section, is now mostly commercial. The view was taken in the vicinity of the Tenth Street intersection of Market Street, looking north. The steeple of St. Paul's M.E. Church can be seen in the distance on the left.

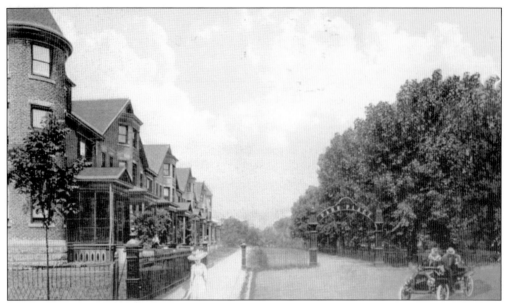

PARK PLACE, C. 1910. This handsome residential area, developed c. 1900 by attorney and real-estate developer W.W. Jackson, consisted of nine row houses facing a common park area. The landscaping and planting was done by Jackson himself. Sometime after the flood of 1913, Park Place was purchased by James H. Creighton, a lumberman. He added five single-family dwellings. This complex was located at the foot of Eighth Street, in close proximity to the Camden Clark Memorial Hospital. During the late 1980s, there was a need for the hospital to expand. The homes were purchased by the city and demolished.

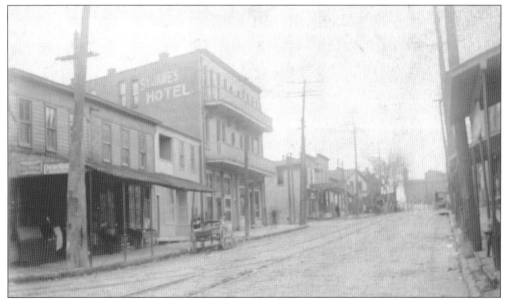

SEVENTH STREET, C. 1912. The St. James Hotel, as seen in this view of Seventh Street looking west, was established around the turn of the 20th century. Although this street has undergone many changes since then, the St. James Hotel building still exists and is now the Legion of Guardsmen. (Courtesy of Bill Miller.)

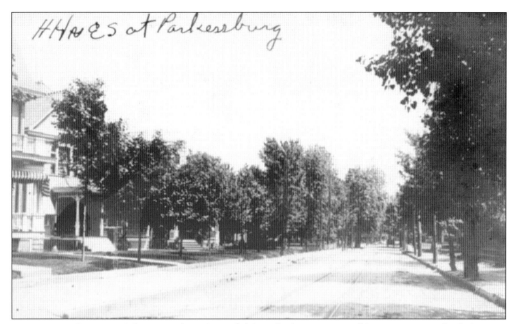

MURDOCH AVENUE. The exact location of this real photo postcard image on Murdoch Avenue in unknown. Although large portions of the street at the time were lined with stylish upper-class homes, there are very few of its original components left today for comparison. Murdoch Avenue was named for the early Murdough/Murdoch families that settled in Wood County.

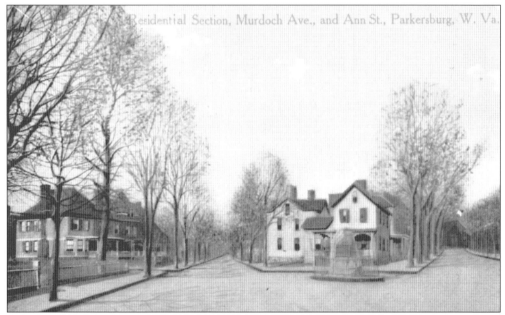

MURDOCH AVENUE AND ANN STREET JUNCTION, 1908. The junction at Murdoch Avenue and Ann Street was a serene residential area early in the 20th century. It is now a busy commercial intersection. In 1908, the James Wood Chapter of the Daughters of the American Revolution erected a massive granite monument here "In memory of the soldiers of the American Revolution born in Wood County." The monument was moved to City Park in 1916.

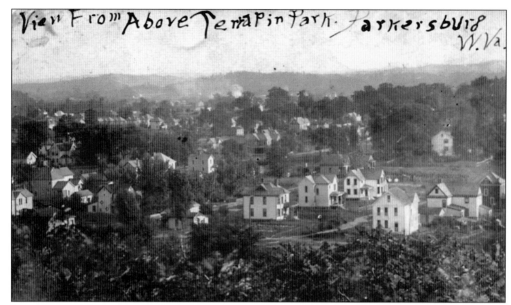

VIEW FROM TERRAPIN KNOB. This image taken from a beautiful elevated area, called Terrapin Knob, captures a glimpse of a newly developing street in town, Vaughan Avenue. According to local historian Alvaro F. Gibbens in 1905, "the knob was a barren spot not supposed to be capable of producing, even by cultivation, black-eyed peas, the abode of only land terrapins." Other accounts suggest that the name "Terrapin Knob" originates from the shape of the hill—curved like that of a turtle. The knob was, at one time, occupied by Native Americans.

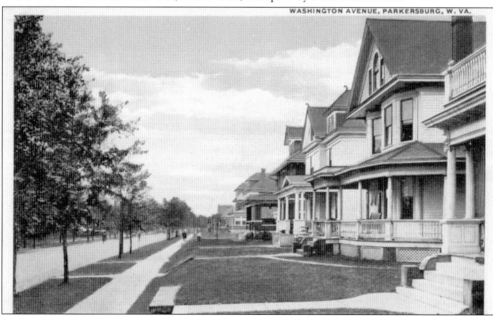

WASHINGTON AVENUE. This view shows the 1200 block of Washington Avenue (also known as Twenty-first Street) looking west to east from the front yard of the Steinbeck home. The first three houses shown were built by Marion H. Flowers in the Queen Anne style. This beautiful tree-lined residential area is now part of the Parkersburg High School–Washington Avenue Historical District.

Two

Prominent Buildings

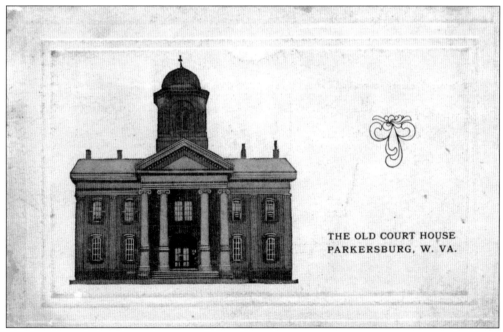

Old Wood County Court House. The old Wood County Court House (1860–1899) was located where the current courthouse now sits. It was a Greek revival building with massive columns topped with Ionic capitals. The huge stones that formed the column bases were the largest ever to be seen in Parkersburg. The building originally had a tall steeple. It was damaged by lightning about 1873 and was remodeled with a cupola. This postcard was produced in the teens as a souvenir of the old structure.

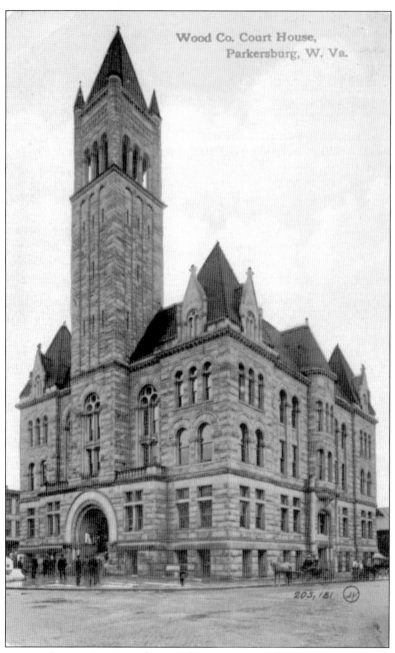

WOOD COUNTY COURT HOUSE. The Wood County Court House is the fifth seat of Wood County government and the third to occupy Court Square. This massive five-story building was constructed between 1899 and 1901 by Caldwell and Drake of Columbus, Indiana. Its architectural design, inspired by one of the greatest U.S. architects, Henry Hobson Richardson, is known as Richardsonian Romanesque and is characterized by massive rough-cut stones, stilted arches, cavernous door openings, and ornamental carvings. One of its most striking features is the tall bell tower. This building was threatened during the 1970s when the city planned to demolish it as part of their Central City Urban Renewal project to revamp downtown. It was saved through the efforts of a few determined citizens and has since been restored.

WOOD COUNTY COURT HOUSE CARVINGS, C. 1915. An unidentified young man in his fashionable tweed suit and cap sits near the steps of the Wood County Court House. The fancy carvings on the courthouse are reminiscent of medieval Europe, where architect Henry Hobson Richardson acquired much of his inspiration. Intricately detailed acanthus leaves, scrolls, a rosette, and a face are carved above the columns. This niche was a popular posing spot for photographs.

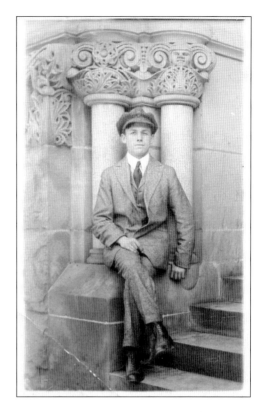

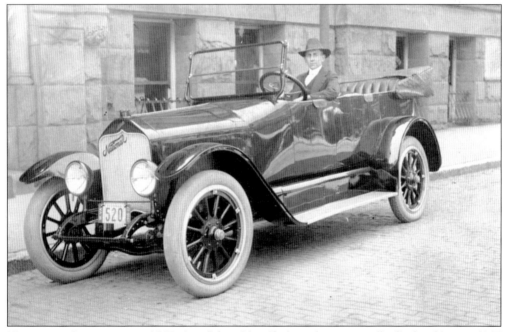

NATIONAL AUTOMOBILE, 1917. A stylish unidentified gentleman proudly displays his new 1917 National six-cylinder touring car alongside the Wood County Court House. Nationals were built in Indianapolis from 1901 to 1924. When new, this fine automobile would have cost $1,750.

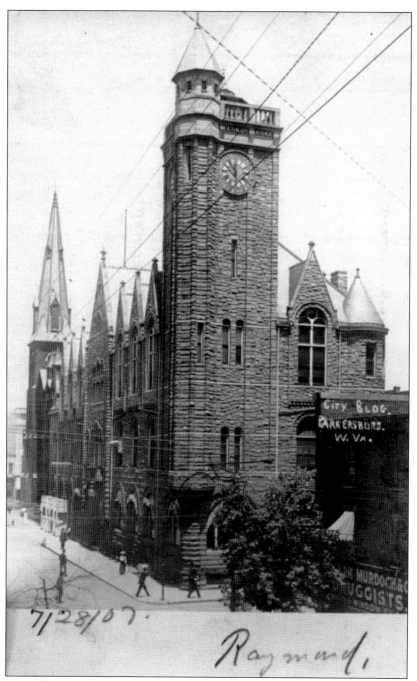

Parkersburg City Building. The city council of Parkersburg issued an ordinance in January 1893 to build a combination city hall and fire department building. They hired contractor T.J. Miller to oversee construction of the new building at the corner of Fifth and Market Streets. Miller must have underestimated this project as it took a year longer to construct than planned and twice the budget. The result was this impressive Romanesque structure that opened for business in October 1897. Local jewelry firm J. Wetherell & Son was contracted to purchase a new clock for the tower. Under much public opposition, the building was demolished in September of 1980.

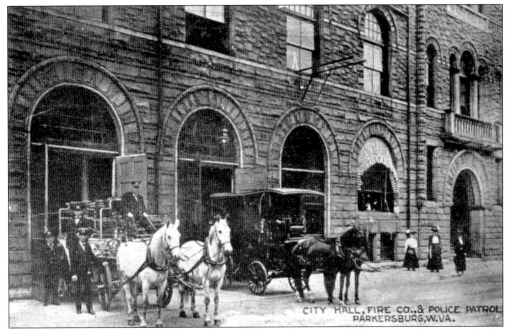

FIRE AND POLICE PATROL, C. 1910. The Police Department and Fire Station #1 were located in the Parkersburg City Building on Fifth and Market Streets. The police department patrol wagon shown here was purchased in 1899 by city ordinance. Around 1900, the city purchased the steam pumper for the fire department. In 1913, both departments purchased their first motorized equipment.

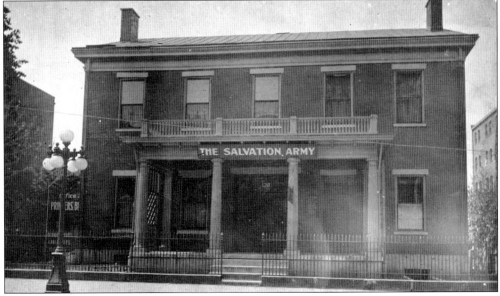

SALVATION ARMY. This building at 120 Third Street was the home of the Salvation Army from 1905 until 1955, when it relocated to Fifth Street. It was built in 1839 as the Northwestern Bank of Virginia (which later became the Parkersburg National Bank). Prior to the Salvation Army's ownership, the structure was the residence of Kate Smith, a reputed harlot.

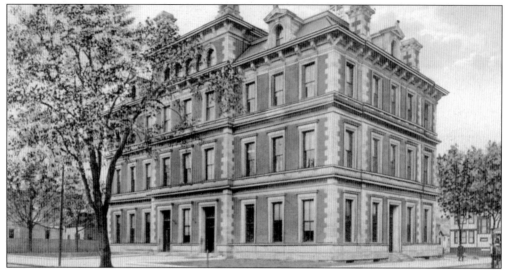

OLD FEDERAL BUILDING. The old brick-and-stone Federal Building located at the corner of Fifth and Juliana Streets was built from 1873 to 1878 at a cost of $378,000. The first floor had 18-foot-high ceilings, and there were marble fireplaces throughout the building. The first floor was occupied by the United States Post Office. The second floor contained many governmental offices, such as the United States Marshal, Collector of Internal Revenue, United States District Attorney, United States Weather Bureau, and the United States Inspector of Customs. On the third floor were the United States District Court Room, judges' offices, and jury rooms. Demolition of the old building started July 31, 1960.

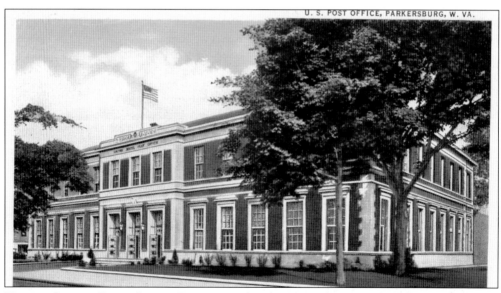

UNITED STATES POST OFFICE BUILDING. This new United States Post Office at the corner of Fourth and Juliana Streets opened on November 13, 1931. Built by contractor Barnes & Company, the building cost $325,000 and took one year to construct. The Collector of Internal Revenue, the Treasury Department, and the Wood County Farm Bureau also occupied portions of the building. The old Federal Building, situated next to the new building, was retained and used for various federal offices until it was replaced in 1960.

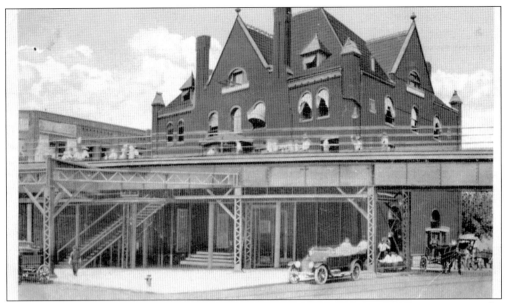

ANN STREET STATION. This building at the corner of Second and Ann Streets served as the terminal for the Ohio River branch of the Baltimore & Ohio Railroad, which ran at the time from Wheeling to Huntington. The three-story brick building was built in 1887. The waiting rooms were on the second floor to give passengers easy access to the elevated train platform. Due to dwindling passenger business, this station's services were discontinued on January 31, 1957. Demolition of the station began in late February 1959.

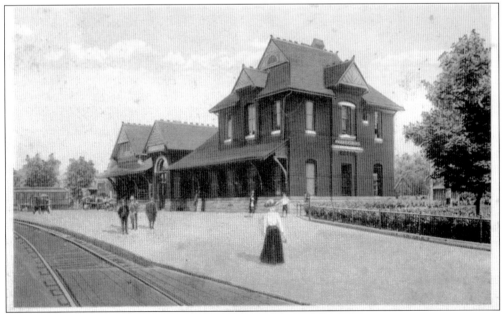

SIXTH STREET STATION. The Baltimore & Ohio Railroad Sixth Street Station was built in 1883, serving the main Baltimore & Ohio line from St. Louis to Baltimore. It was located along Sixth Street on the block between Avery and Green Streets. It was demolished on November 6, 1973, to make way for a parking lot for the new PNB Square by the Parkersburg National Bank.

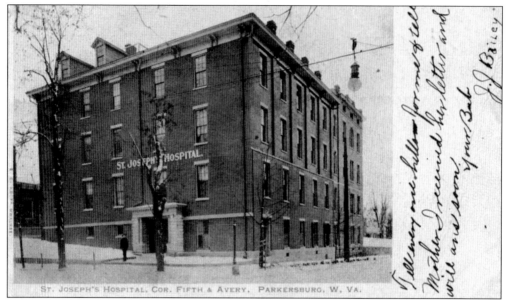

OLD ST. JOSEPH'S HOSPITAL. The Sisters of St. Joseph, a sisterhood devoted to God and mankind, came to Parkersburg in 1900 to start a parochial school. Under the direction of Bishop Donahue, the Sisters purchased the building recently vacated by the Sisters of Visitation and converted it into a hospital. Chartered on April 3, 1902, the old St. Joseph Hospital located at Fifth and Avery Streets is shown in this postcard. The building was torn down in the 1940s to construct the Sears Department Store.

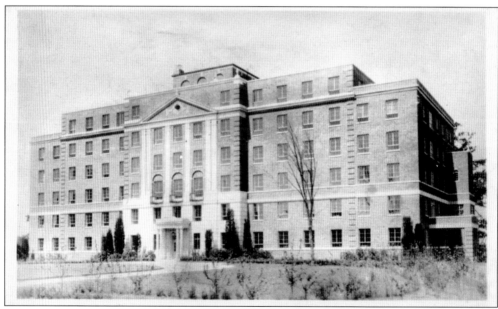

ST. JOSEPH'S HOSPITAL, 1932. A campaign was started in October 1929 to upgrade the Fifth and Avery Streets hospital building by adding a new addition. The campaign was so successful, raising over $332,000, that they decided to build a new hospital at the edge of town. Property was purchased at Nineteenth Street and Murdoch Avenue from the McConaughay estate. This Italian-style building was opened to the public on October 13, 1931.

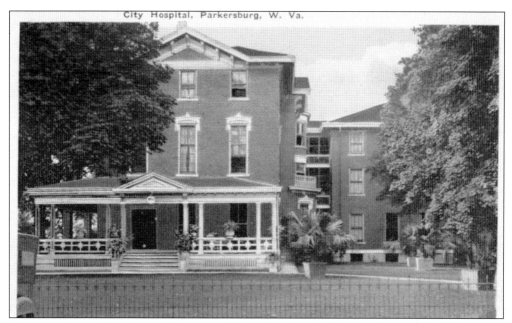

CAMDEN CLARK MEMORIAL HOSPITAL. The facility that we know as Camden Clark Memorial Hospital began with the donation of the Camden family home to the City of Parkersburg in 1918. The home, located at 717 Ann Street, required major modifications and additional space to function as a hospital. Through donations from Dr. Andrew Clark and others, an annex was built to the right of the home. The completed hospital was opened and dedicated on April 16, 1920.

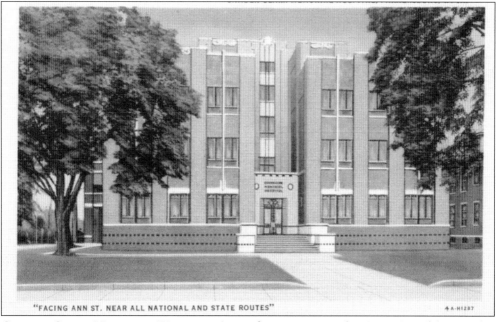

CAMDEN CLARK MEMORIAL HOSPITAL. A new front entrance and patient wing of the Camden Clark Memorial Hospital was started in the early 1930s. The three-story expansion was funded through city bond issues and grants from the Public Works Administration. The addition shown in this postcard was called the East Wing and was completed in 1936.

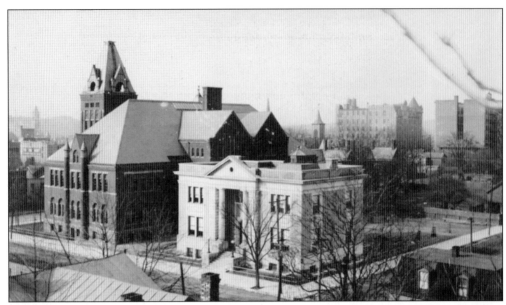

CARNEGIE LIBRARY, C. 1910. The Carnegie Library, predecessor of the Parkersburg and Wood County Public Library, was located at the corner of Eighth and Green Streets. The old Parkersburg High School building can be seen beside it. The library was built with funds from Andrew Carnegie and operated here from 1905 through 1974, when the current Emerson Avenue public library opened. The building featured a spectacular central wrought-iron and brass spiral staircase, unique glass-tiled floors, and beautiful woodwork. It is now home to Trans Allegheny Books.

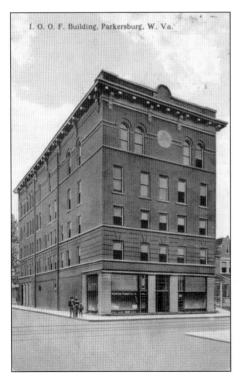

I.O.O.F. BUILDING. Parkersburg Lodge No. 7 of the International Order of Odd Fellows had this building constructed in June 1913 at the corner of Ninth and Market Streets. The official dedication of the building occurred in October 1913, when about 1,200 to 1,500 lodge brothers descended into Parkersburg for a Grand Lodge Convention.

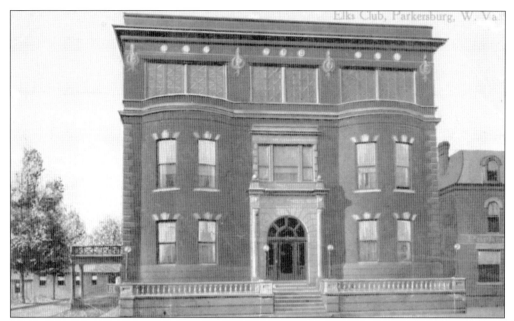

ELKS CLUB, C. 1910. The Parkersburg Benevolent and Protective Order of Elks Lodge #198 was chartered in 1891 as the 198th Elks lodge in the country and the second in West Virginia. After having met at various bank buildings, the lodge erected this building at 515 Juliana Street for a cost of $51,000. The cornerstone was laid November 26, 1903, and the formal opening was on December 27, 1904.

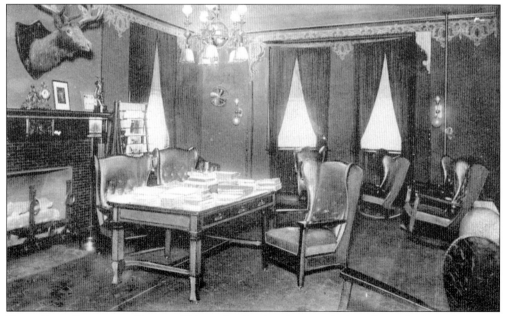

ELKS CLUB LOUNGING ROOM. This undated printed postcard view shows the lounging room at the Elks Club. It is handsomely decorated with a central reading table and massive leather lounge chairs. The mounted elk's head still overlooks this room today; however, major remodeling projects of the 1950s and 1960s have changed the overall look.

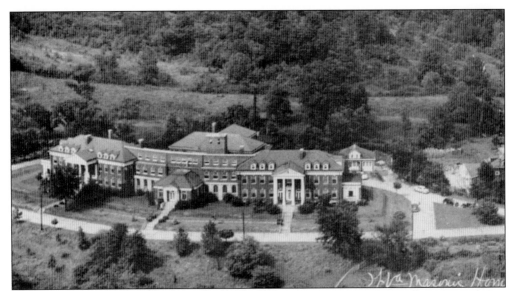

WEST VIRGINIA MASONIC HOME. The West Virginia Masonic Home opened in June 1924 as a home for dependents of Masons. Construction of the large brick-and-stone facility began in 1921. It consisted of two two-and-a-half-story wings, one for men and the other for women and children, with an administration building in the center joined by corridors. It included an auditorium, social and study rooms for the children, a library, and an infirmary. It could accommodate 100 residents at a time. The home continues to be a residence for men and women of the Masonic Lodge.

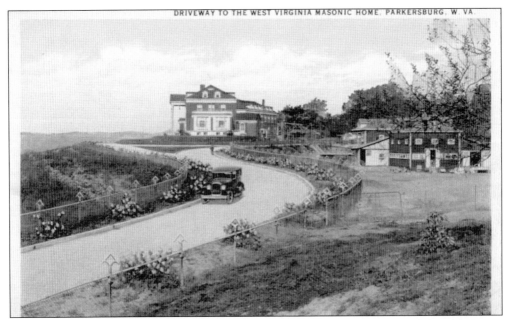

MASONIC HOME DRIVEWAY. The West Virginia Masonic Home is situated on a beautiful 80-acre hilltop tract of land. The landscaped grounds were enhanced by this graceful, flower-lined driveway. During the early years, the home was very self-sufficient, growing large quantities of garden vegetables and maintaining an orchard. They also kept a small herd of cattle on the property.

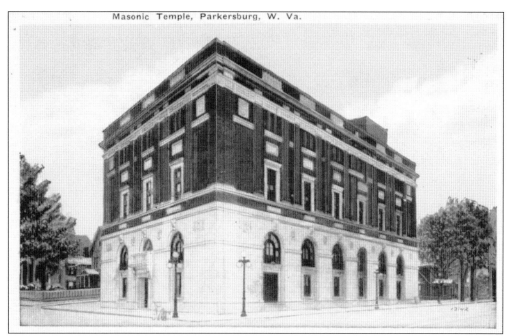

MASONIC TEMPLE, C. 1920. The Masonic Temple, located at the corner of Ninth and Market Streets, was constructed from 1915 to 1917. The attractive four-story, stone-and-brick Classical Revival building includes a spacious banquet hall and ballroom. It houses many appendants of the Masonic Order as well as several ladies' organizations.

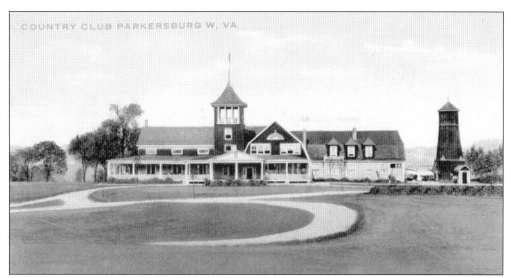

PARKERSBURG COUNTRY CLUB, C. 1910. The Parkersburg Country Club, formed by James S. McCluer and Orie O. Tolles and designed by architect William Howe Patton, formally opened on June 11, 1903. Built on the Seldon Stone property six miles above Parkersburg, it functioned as a resort for the social elite. The building had a maple wood dance floor, electric illumination by its own electric plant, and a water supply fed from a 100-barrel water tower. A fire in May 1936 completely destroyed the building. A new country club was built at the same location and is still in business today. (Courtesy of Dave McKain, Oil and Gas Museum.)

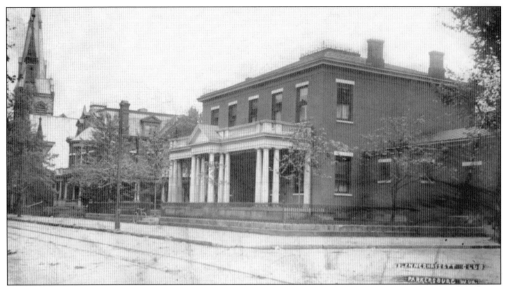

BLENNERHASSETT CLUB, C. 1906. In October 1894, 20 local men of Parkersburg formed a new gentlemen's social organization called the Blennerhassett Club. In 1901, they purchased the John Valleau Rathbone home at Fourth and Juliana Streets for $19,000 as a clubhouse. After the organization moved to a new home on Seventh Street, the building was divided up into small offices. The building was torn down in the mid-1980s and converted into a parking lot.

AMERICAN LEGION HOME, 1948. Built in 1867 as the residence of Federal Judge John Jay Jackson Jr., this magnificent estate originally covered the entire block between Quincy and Green Streets. It was very posh and furnished with the best. Later, portions of the land were sold off, leaving it with the address of 519 Seventh Street. It was called "Carrinda" after Jackson's wife, Carrie. After the judge's death, it passed to his unmarried daughter, Lily Irene, and after her death was used as apartments. In 1946, the American Legion purchased it for a member clubhouse and remained there until 1973. It burned down on February 27, 1976, a few weeks after the structure had been turned into a nightclub called Club Carrinda.

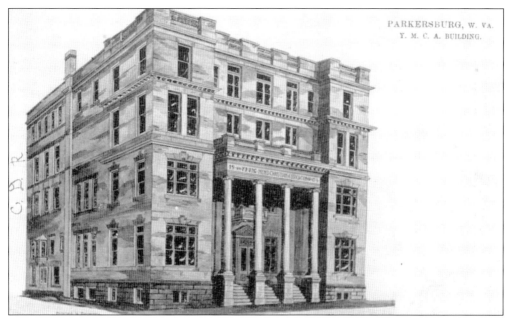

YMCA. The Young Men's Christian Association's (YMCA) first permanent building in Parkersburg was this impressive four-story structure at 217 Eighth Street. The cornerstone was laid June 9, 1904, and the dedication was October 8, 1905. The facility included reading and clubrooms, a gymnasium, an auditorium, a swimming pool, dormitory rooms, and more. The building was demolished in January 1965.

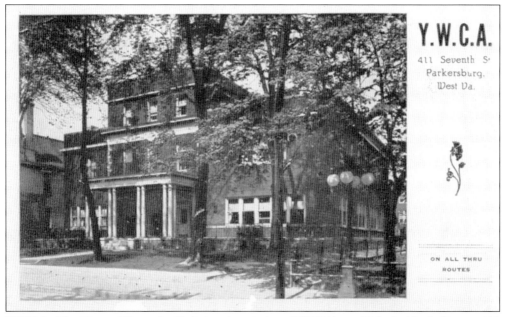

YWCA. The Young Women's Christian Association (YWCA) established this facility at 411 Seventh Street in 1920. It offered a cafeteria, dining room, clubrooms, and bedrooms. Dormitory rooms were available at monthly rates for independent young women. Daily rates applied for nightly lodging. The building was used by the YWCA until 1975.

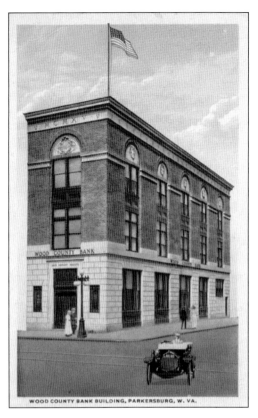

WOOD COUNTY BANK, 1916. Chartered on March 8, 1894, Wood County Bank was located at Fifth and Market Streets. In 1915, bank officers decided to remodel the building to reflect their status in Parkersburg's financial circle. The architectural firm of Dennison & Hirons of New York City added granite slabs to the first floor and stone on the upper floors. Wood County Bank became Commerce Bank in 1994 and in 1997 became Huntington Bank.

PARKERSBURG NATIONAL BANK, 1915. In 1839, a branch of the Northwestern Bank of Virginia opened in Parkersburg on Third Street. They reorganized in June 1865 and became the Parkersburg National Bank. Then, for a time, the bank occupied part of the first floor of the Blennerhassett Hotel. On March 17, 1915, they opened this new building at 514 Market Street. The bank became United National Bank in 1986 and United Bank in 2002. On St. Patrick's Day, ever since 1874, the bank celebrates its anniversary by giving shamrocks to customers.

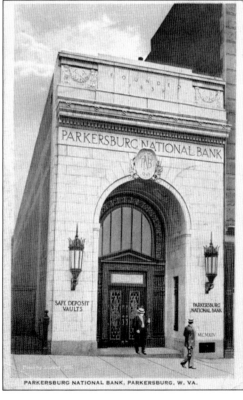

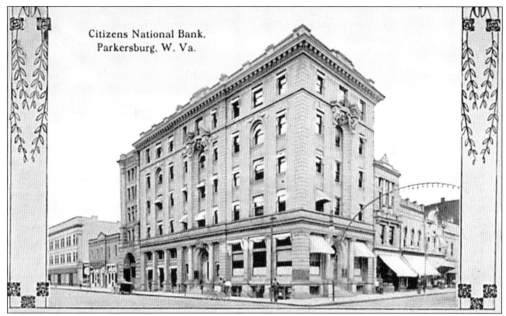

CITIZENS' NATIONAL BANK AND GUARANTY BUILDING. The Citizens' National Bank was organized in July 1882. The bank built this five-story stone-and-brick office building, located on the corner of Fourth and Market Streets, in 1898. The four-story Guaranty Building, which was built up against the bank building on the Fourth Street side, was demolished in 1992. The three-story John W. Mather's jewelry store building was built up against the bank building on the Market Street side. The bank struggled through the Depression and finally merged with the Parkersburg National Bank in 1935.

UNION TRUST BUILDING. This office building, located at the corner of Seventh and Market Streets, was built by Johnson N. Camden. The Union Trust and Deposit Company moved into it on July 4, 1904. The four employees of the company occupied a part of the first floor. The structure is seven-stories high and has a U-shaped floor plan. Since 1923, one prominent feature of the building has been a clock on the building's corner. Mountain State Blue Cross Blue Shield, who currently resides in the building, now maintains a digital clock there.

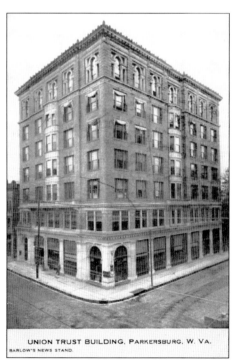

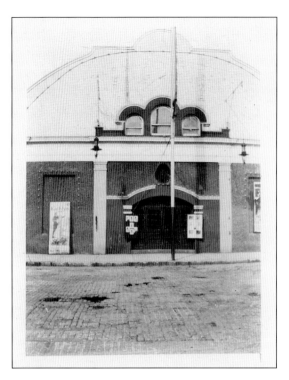

HIPPODROME "HIPP" GARDEN THEATER, C. 1914. Built as the open-air Airdome in 1909 by brothers Ed and Riney Hiehle, this theater was rebuilt with a roof and renamed Hippodrome, opening on November 28, 1910. It offered both vaudeville and motion pictures. The Adventures of Kathlyn series, movie #6, *Three Bags of Silver*, was the silent film featured when this photo was taken. The Hippodrome was torn down in 1925. The Smoot Theater now occupies this site. (Courtesy of Dr. John E. Beane.)

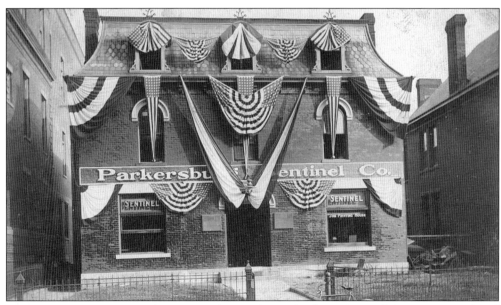

PARKERSBURG SENTINEL COMPANY, 1917. The Parkersburg Sentinel Company purchased the old Max Thanhouser brick Victorian home in 1910 from Albert Stiles. It was located at 519 Juliana Street. This served as the fourth location for the Parkersburg Sentinel Company since its establishment in 1875. In this view, the building is patriotically decorated, probably either for the big welcome home event for Companies A and E of the West Virginia Infantry returning home from the Mexican border or as a farewell for the local boys departing for World War I service. (Courtesy of Dr. John E. Beane.)

CAMDEN THEATER, 1914. The Camden Theater, Parkersburg's most elegant theater, opened on September 10, 1902. Situated on the west side of Market Street between Seventh and Eighth Streets, it took up one-half of the city block. Seating was composed of three layers (main floor and two balconies), plus several private boxes. This enabled the theater to accommodate 1,400 people. Initially designed for live performances, the Camden, like most theaters at that time, had to adjust to changing times and also offer silent movies. At the time of this photograph, the Camden was featuring the film *The Spider* starring the stunning silent film beauty Pauline Frederick. (Courtesy of Dr. John E. Beane.)

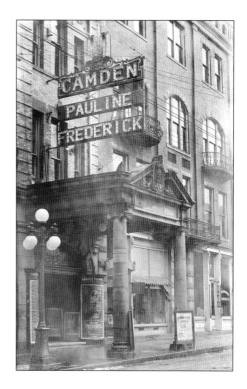

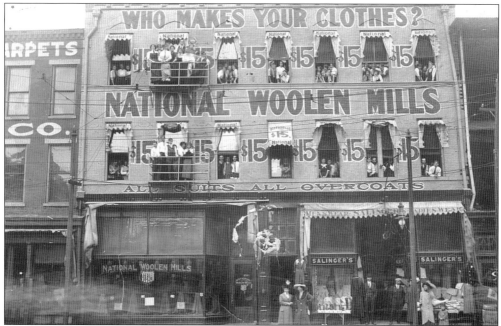

NATIONAL WOOLEN MILLS & SALINGER'S CLOTHING. The Boso family started a men's and women's clothing company in 1910 called the North American Woolen Mills. Within months, the company officials decided that a new name was needed, and by December of that year, the National Woolen Mills was formed. They occupied 231 Court Square for 15 years. The business closed in 1929. (Courtesy of Dr. John E. Beane.)

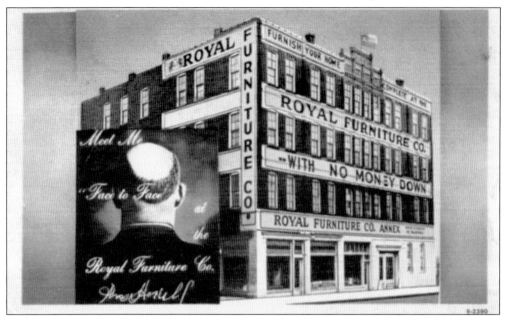

ROYAL FURNITURE COMPANY ANNEX. The Royal Furniture Company, established in 1927, was owned and operated by William Howell. The photo insert, depicting the back of Mr. Howell's head, reads "Meet me face to face." This annex building was located at 120 Fourth Street. It later became Parkersburg Paint. It was demolished sometime between 1975 and 1980.

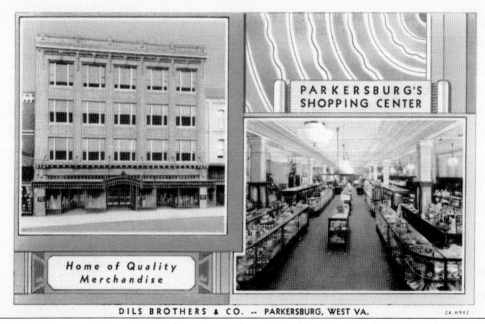

DILS BROTHERS & CO., 1942. This retro-modern printed postcard is advertising Dils Brothers & Co. The company was formed by Henry H. Dils and Samuel M. Dils and opened its doors March 14, 1900. In 1906, the store was relocated to this larger building at 521 Market Street. The upscale department store occupied this area until they closed in 1988.

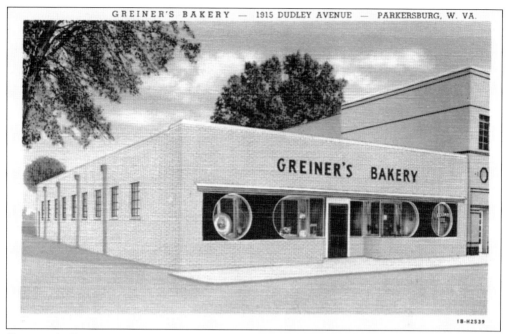

GREINER'S BAKERY, 1941. A.L. Greiner established a successful bakery at 811 Seventh Street on May 20, 1934. While Mr. Greiner baked, his wife waited on the customers. Outgrowing that facility, he purchased property at 1915 Dudley Avenue and constructed a new 5,200-square-foot building. This location opened its doors in July of 1941.

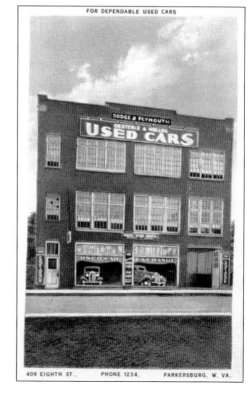

OESTERLE & MULLEN, 1939. Started by Earl J. Oesterle and J. Vincent Mullen in 1923, this business sold new Dodge and Plymouth automobiles, as well as a variety of used cars. The business had several locations but moved to 409 Eighth Street in 1937 and stayed at that spot for five years. The business became Mullen Motors in 1944.

DUDLEY'S FLORIST, FIFTH STREET STORE, C. 1910. J.W. Dudley & Sons established their first store at 119 Market Street selling meat, vegetables, and flowers. By 1880, the store had relocated to 519 Market Street. The store pictured here, located at 201 Fifth Street, was opened in October of 1904. In later years, their main florist facility and greenhouses were on Dudley Avenue. The Fifth Street Store continued to offer customers a convenient downtown location until it was discontinued and demolished in 1997. The old First Methodist Church can be seen on the right. (Courtesy of Dr. John E. Beane.)

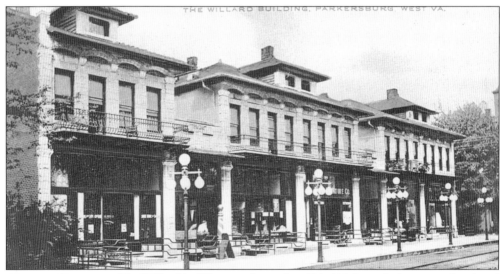

WILLARD BUILDING. The Willard building was located at 400-412 Seventh Street, on the site of the former home of Gov. Jacob Beeson Jackson. It was built *c.* 1912 by the governor's son, William Wirt Jackson, and named after William Wirt's son, William Willard Jackson. The first floor was a row of rental units occupied by both retail stores and service enterprises. Over the years, they housed a florist, a typewriter repair shop, barbers, hairdressers, stores, taverns, etc. The second floor consisted of apartments. In March 1983, the Willard building was acquired for its property by a banking company and demolished. Magnet Bank was built on the site. (Courtesy of Dr. John E. Beane.)

Three

STOREFRONTS AND BUSINESS INTERIORS

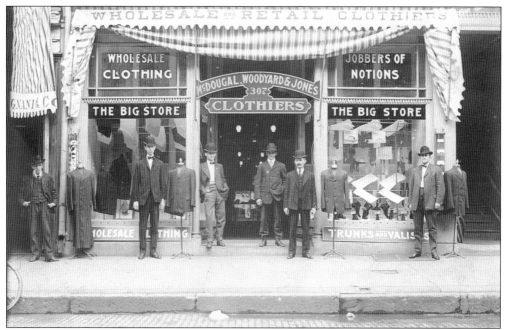

MCDOUGAL, WOODYARD & JONES, CLOTHIERS, C. 1906. The store of McDougal, Woodyard & Jones, located at 307 Market Street, was a wholesaler and retailer of fine men's clothing. It offered hats, vests, jackets, shirts, ties, collars, and also luggage and trunks. The store was operated by L. Meade McDougal, Burdette Woodyard, and W.R. Jones. (Courtesy of Dr. John E. Beane.)

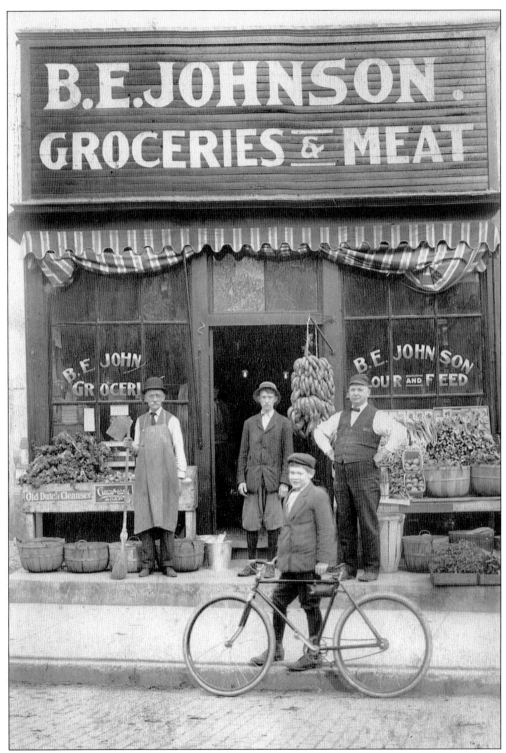

JOHNSON GROCERY. Bennett E. Johnson operated this grocery store at 1901 Murdoch Avenue. He sold fresh vegetables, meat, flour, and animal feed. (Courtesy of Dr. John E. Beane.)

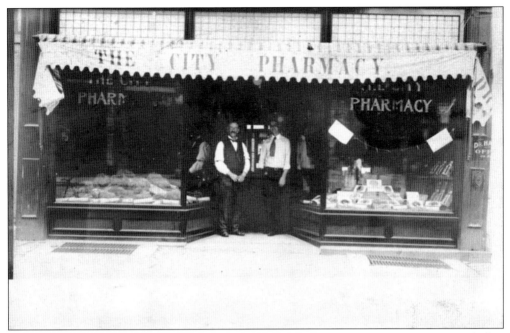

CITY PHARMACY. The City Pharmacy was established in 1914 by Okey J. Stout and Campbell A. Neptune. It was located at 500 Market Street and remained in business there for a long time.

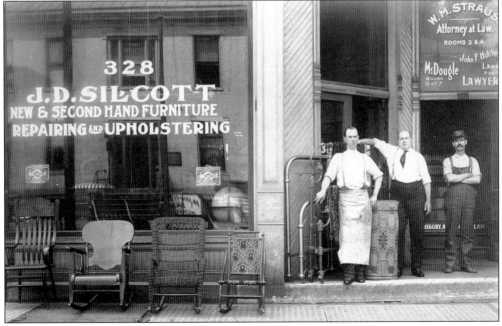

J.D. SILCOTT, C. 1910. Jesse Delbert Silcott operated this new and secondhand furniture business at 328 Juliana Street. He later relocated to 210 Fourth Street. This Juliana Street building was later demolished as part of the 1970s urban renewal project. (Courtesy of Dr. John E. Beane.)

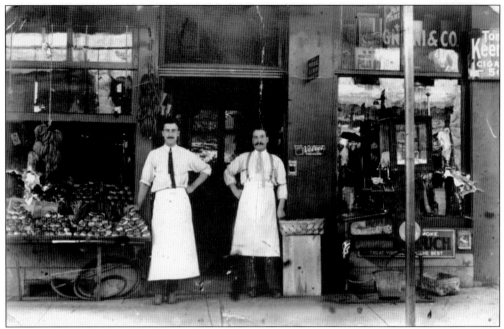

MAGNANI & CO. Italian storekeeper Ettori Magnani operated this store at 514 Market Street. Although he specialized in foreign and domestic fruit, he also sold peanuts, popcorn, ice cream, cigars, and tobacco.

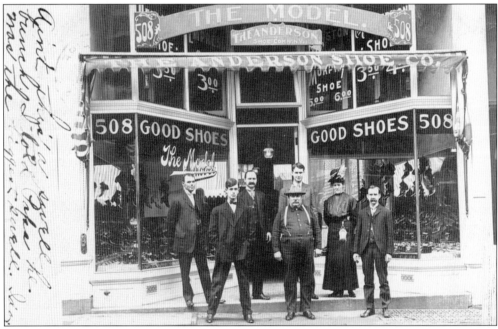

THE MODEL SHOE STORE. The Model Shoe Store, located at 508 Market Street, was owned and operated by Edward and James Anderson of the Anderson Shoe Company. They sold high-quality footwear for both men and women. Their specialties cost from $3.50 to $5. (Courtesy of Dr. John E. Beane.)

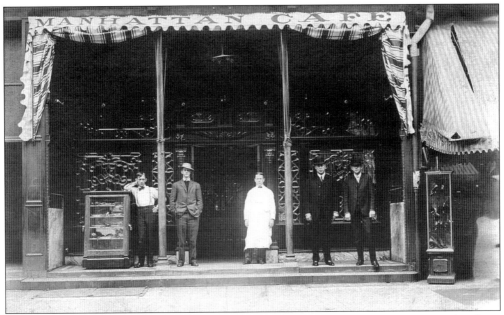

MANHATTAN CAFE. The Manhattan Cafe, a barroom and restaurant, was open day and night. It was located at 313 Market Street and had a magnificent leaded glass storefront. Lewis H. Logan and Clarence H. Leach were the proprietors. It was in operation from approximately 1900 to 1915. (Courtesy of Dr. John E. Beane.)

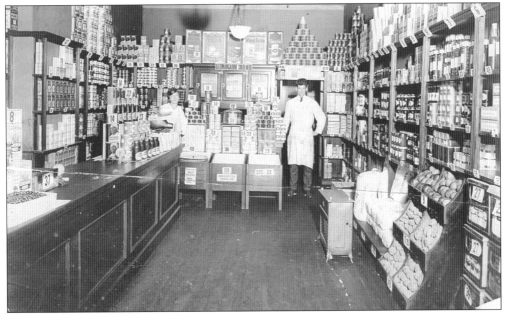

PARKERSBURG A&P STORE, C. 1915. This A&P grocery store was located at 525 Market Street. Shown in the picture are Anna T. Acton, manager, and Joseph M. Acton, clerk. The Great Atlantic and Pacific Tea Company was the first national supermarket chain in the United States. A&P offered many of its own store brands, premiums, and savings coupons. (Courtesy of Dr. John E. Beane.)

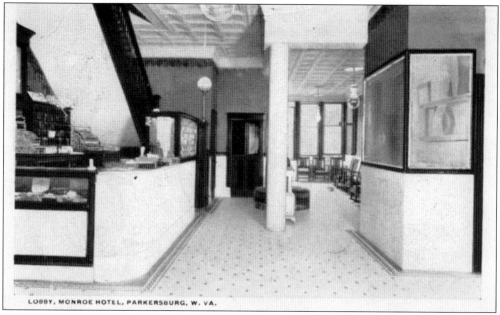

LOBBY, MONROE HOTEL, PARKERSBURG, W. VA.

MONROE HOTEL LOBBY. The four-story Monroe Hotel was constructed in 1899 by wealthy businessman James Monroe Jackson and was located at the southeast corner of Court Square. Called the "Monroe" after the owner's middle name, the hotel ran into hard times in the spring of 1905. To make the business profitable once more, major improvements to the dining room, kitchen, and sleeping rooms were made.

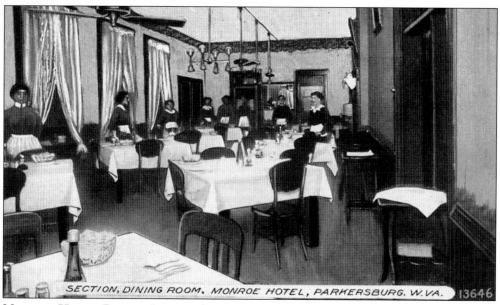

SECTION, DINING ROOM, MONROE HOTEL, PARKERSBURG. W.VA. 13646

MONROE HOTEL DINING ROOM. The dining room of the Monroe Hotel is shown in this postcard during its peak time of prosperity. During its later years, the hotel acquired a bad reputation brought about by ladies such as the infamous Mabel M., who purchased her favorite perfume by the gallon at a local drug store. The building was finally destroyed by a fire on November 19, 1969. (Courtesy of Dave McKain, Oil and Gas Museum.)

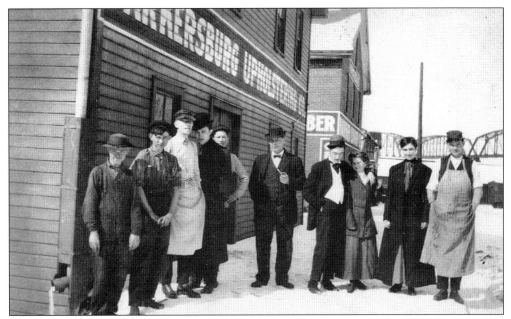

PARKERSBURG UPHOLSTERY COMPANY. The Parkersburg Upholstery Company, incorporated in 1892, operated out of this large, two-story frame building located at 44 Fifth Street. One of its stockholders was William Bentley of Bentley & Gerwig Furniture Company. The company employed about 20 skilled workers. They specialized in the upholstery of parlor suits, lounges, leather-covered rockers, and fancy couches. This postcard view shows a group of unidentified workers standing in front of the business. The building in the background is Radeker Lumber at 42 Fifth Street. (Courtesy of Paul Borrelli, Artcraft Studio.)

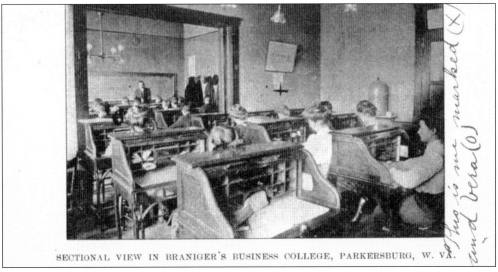

BRANIGER'S BUSINESS COLLEGE, C. 1907. Braniger's Business College, established by Prof. Charles A. Braniger, was located on the fourth floor of the Citizens' National Bank building on Market Street. The school was discontinued in April 1909. It was sold to Marietta Commercial College just weeks prior. Marietta Commercial College had intended to operate the school here as its branch but later decided to discontinue it.

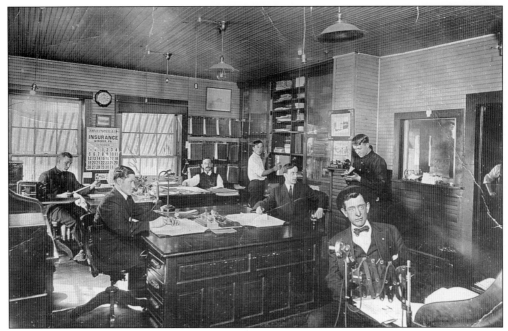

SHATTUCK AND JACKSON GROCERS, 1913. This wholesale grocery firm was created by Charles Horace Shattuck and James Monroe Jackson. This picture shows a busy office in their building located at 321–325 Ann Street. (Courtesy of Dr. John E. Beane.)

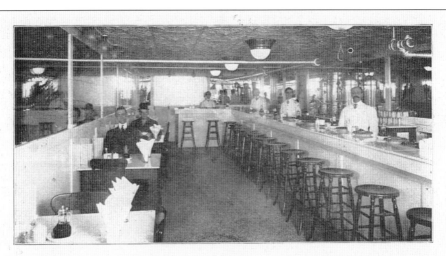

BIJOU DAIRY LUNCH RESTAURANT. The Bijou Dairy Lunch restaurant was established in 1909 by Xenophon Fochalis, a Greek immigrant who came to the United States in 1905. It was located in the basement of the United Woolen Mills Building, at 302–304 Market Street. Mr. Fochalis was also the proprietor of a second restaurant, the Crescent Dairy Lunch restaurant, located at 601 Market Street. He sold his business interests in both restaurants in 1912. (Courtesy of Dr. John E. Beane.)

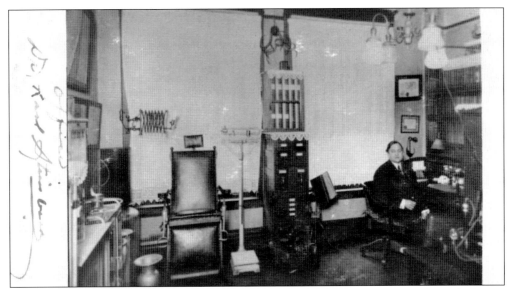

DR. KARL STEINBECK'S OFFICE. Dr. Karl Steinbeck (1881–1940), son of Daniel F. and Ellenora Steinbeck, was a Parkersburg physician and surgeon for over 30 years. He received his medical degrees from the College of Physicians and Surgeons in Baltimore. His brother Harry was a dentist. Dr. Karl Steinbeck and Dr. Harry Steinbeck had offices across the hall from each other at 612 1/2 Market Street, near the Chancellor Hotel. (Courtesy of Blennerhassett Island Historical State Park.)

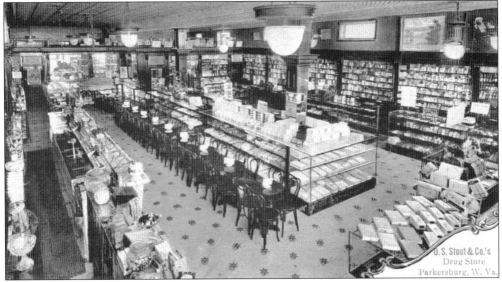

O.J. STOUT & CO.'S DRUG STORE. Stout's Drug Store, established in 1897, was located at 531–533 Market Street in 1915. It was beautifully decorated with Italian marble, Tiffany art glass, and hand-carved mahogany woodwork. In those good old days, the local drug store offered not only pharmaceutical items, but also a variety of goods and services, such as dime-store-type merchandise, cameras, cosmetics, stationery goods, and a soda fountain/restaurant. Stout's remained on Market Street until 1983 when it relocated to Dudley Avenue. (Courtesy of Dr. John E. Beane.)

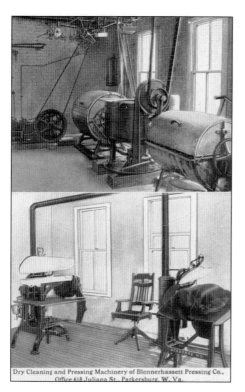

BLENNERHASSETT PRESSING CO. INTERIOR, 1916. Dorr Smith, originally of Racine, Ohio, settled in Parkersburg in 1896. He entered the dry-cleaning business and by 1905 established the Blennerhassett Pressing Company on Juliana Street. In 1912, he operated his dry-cleaning workshop out of this small brick building at the rear of 1809 Spring Street, while maintaining an office at 618 Juliana Street. Today, as far as Parkersburg collectible postcards are concerned, this is one of the rarest, with only a few known to exist. (Courtesy of Dr. John E. Beane.)

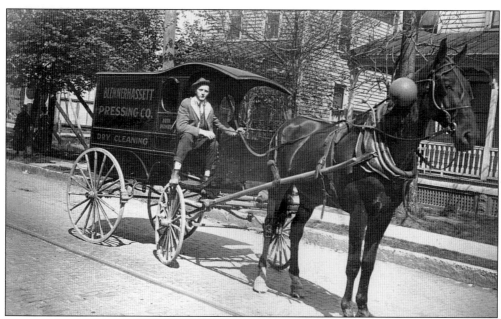

BLENNERHASSETT PRESSING CO. DELIVERY WAGON. Driver Clarence Daggett is shown in the Blennerhassett Pressing Company's delivery wagon in front of 1807 Spring Street. Dorr Smith, the proprietor, was in the dry-cleaning business for 38 years. His dry-cleaning building at the rear of 1809 Spring Street still exists and is now the Ye Old Furniture Repair Shop. (Courtesy of Dr. John E. Beane.)

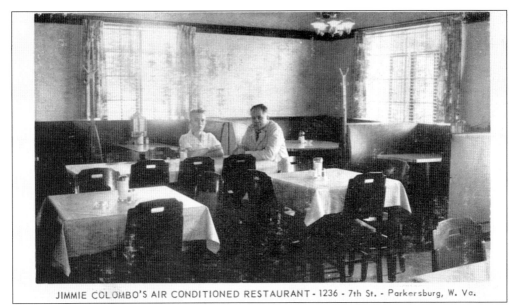

JIMMIE COLOMBO'S RESTAURANT, 1954. James B. Colombo and his wife, Anna, sit in the restaurant they established in 1954 at 1236 Seventh Street. Managing this fine restaurant is a family tradition, passing down to son James E. Colombo and now under the guidance of grandson James M. Colombo. The restaurant has grown from 50 seats in the 1950s to currently 400 seats. It offers a variety of Italian and American cuisine. (Courtesy of Dr. John E. Beane.)

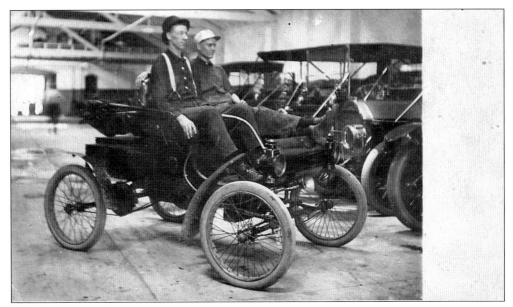

PARKERSBURG AUTOMOBILE COMPANY GARAGE. The Parkersburg Automobile Company was formed in April 1905 to offer a place for people to purchase, sell, lease, or store their autos. Business grew rapidly, and within a few months, they had contractor A.N. Flinn to construct a brick garage at 607 Juliana Street. Shown here are two unidentified men sitting in a 1901 one-cylinder curved dash Oldsmobile inside the Parkersburg Automobile Company Garage. (Courtesy of Dr. John E. Beane.)

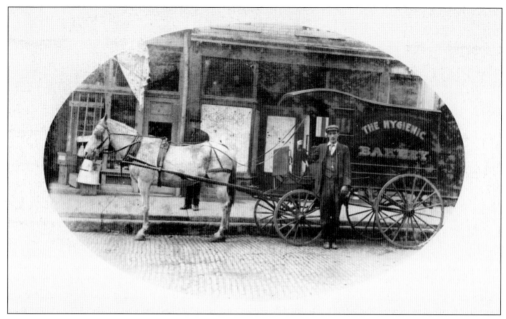

HYGIENIC BAKERY, C. 1914. Laurence E. Robinson operated a bakery at 1400 Seventh Street for many years. In 1914, the bakery was leased to Thomas H. Mathews who renamed the business the Hygienic Bakery. Mathews operated his bakery at this location for several years.

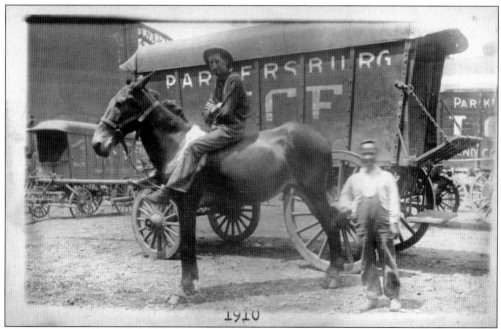

PARKERSBURG ICE COMPANY. The Parkersburg Ice Company, incorporated in 1887, was a large establishment located at the foot of Sixth Street near the Ohio River Railroad tracks. Local deliveries of ice were handled by these delivery wagons. The company also shipped ice by railroad to surrounding communities such as Point Pleasant, Ravenswood, and Sistersville. (Courtesy of Blennerhassett Island Historical State Park.)

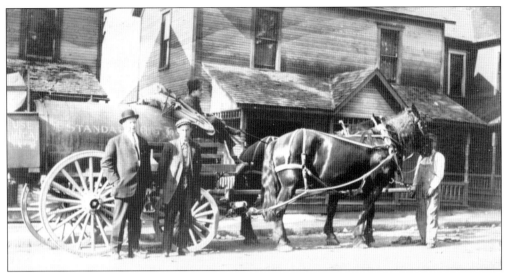

STANDARD OIL TANK WAGON. The Standard Oil Refinery in Parkersburg produced benzene, kerosene, axle grease, lubricating oils, paraffin wax, and more. Shown here is one of their delivery tank wagons that probably carried a supply of kerosene or lamp oil for delivery to local retail establishments. This real photo postcard image is believed to have been taken on Mary Street, not far from the refinery. Pictured wearing the derby hat and suite is the oil company president, Vinton Rathbone.

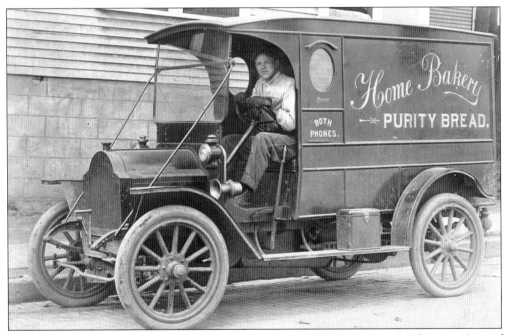

HOME BAKERY. Home Bakery was started in 1909 at 928 Seventh Street by four members of the Barrett family: Edward, Anne, Margaret, and Mary. Shown in this photo is the Home Bakery's 1914 Commerce delivery truck. The name was changed to Barrett's Bakery in the early 1920s. After the death of several members of the Barrett family in the early 1940s, the bakery was closed. (Courtesy of Dr. John E. Beane.)

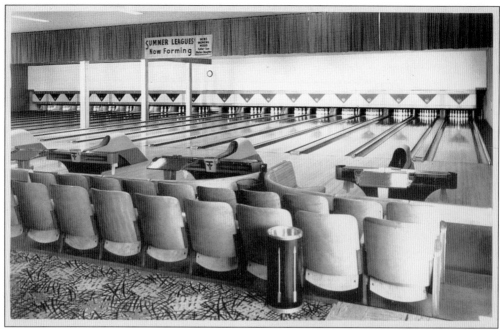

EMERSON BOWLING LANES, C. 1955. Emerson Bowling Lanes, located at 1501 36th Street, was built by Mark Nichols and Jim Chacona. It first opened its doors on March 15, 1949, with eight lanes and by 1955 had been remodeled and fitted with 20 lanes, as seen above. It now has 46 lanes. (Courtesy of Dr. John E. Beane.)

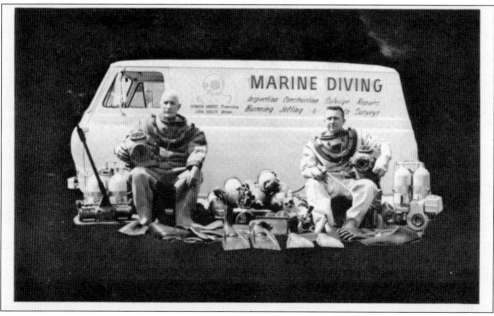

MARINE DIVING, 1964. Two divers from the Army Corp of Engineers, Stan Halley (on the left) and Howard Haverty (on the right), started a marine diving business on Edgelawn Street in south Parkersburg in the early 1960s. Stan Halley was known as "the best hardhat diver of the Ohio River." At the time, the divers had a combined 45 years of Ohio River experience.

Four

Hotels, Motels, Tourist Homes, and Flats

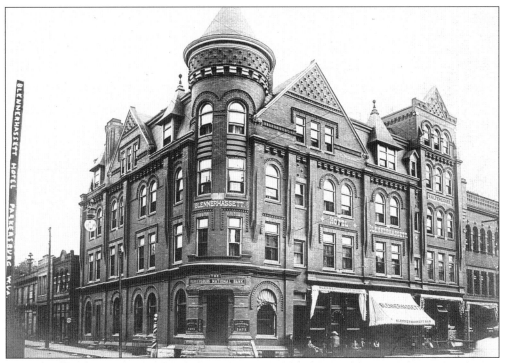

BLENNERHASSETT HOTEL. Shown here is the Blennerhassett Hotel and surrounding buildings on the southeastern corner of Fourth and Market Streets. The hotel was built by William Nelson Chancellor and opened in 1889. One of its most distinguishing features is the five-story tower at the front corner. Its architecture has been described as both Eclectic and Romanesque. Parkersburg National Bank occupied a portion of the first floor. The hotel is still operating today and has been beautifully renovated and expanded. (Courtesy of Dr. John E. Beane.)

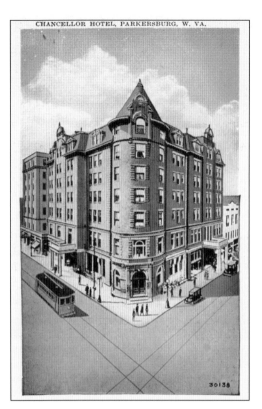

CHANCELLOR HOTEL. This grand hostelry, located at the corner of Seventh and Market Streets, was opened for business on June 1, 1903. It was built by the Bank Block Investment Company and named after William Nelson Chancellor. The building was durably constructed of concrete and steel and considered fireproof. There were initially 120 guestrooms with a 1924 addition adding 100 more. The hotel was demolished in 1977 and is now a parking lot.

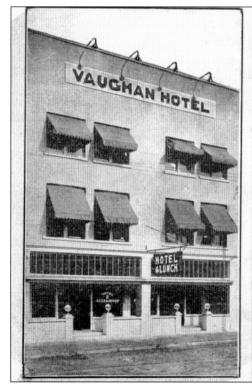

VAUGHAN HOTEL. The Vaughan Hotel, conveniently located across from the Baltimore & Ohio Sixth Street Station at 411 Sixth Street, was owned by Herbert Chester and Ida Hazel Vaughan from approximately 1921 to 1926. The room rate was $1 per day. Prior to 1921, it was known as the Capital Hotel. (Courtesy of Dr. John E. Beane.)

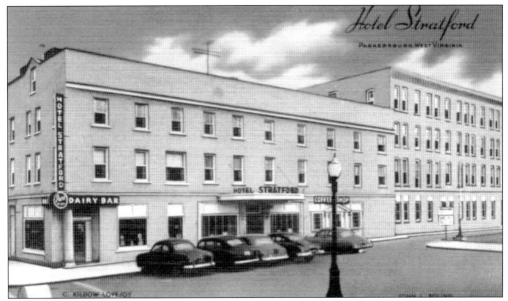

HOTEL STRATFORD. This structure has a long history, having been built c. 1820 as the Bell Tavern and renamed several times since: United States Hotel, Hill's Central Hotel, Commercial Hotel (during which time the four-story addition was added), briefly as the Princess Hotel, and becoming the Stratford in 1925. In June 1967, it was purchased by the Hanna family and renamed the Mark Hanna. Around 1970, the Center City Urban Renewal project was created to modernize portions of downtown Parkersburg. Unfortunately this historic structure was within the boundaries of the project and was demolished in August of 1972.

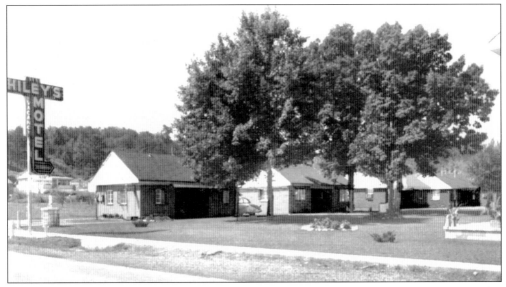

"HILEY'S MOTEL—WHERE YOU CAN SLEEP AND EAT." In April 1936, Raymond D. Hiley purchased property at 2610 Pike Street in south Parkersburg and established Hiley's Motel as a group of individual tourist cabins. He ran the establishment for 21 years. The property was previously a dance hall, barbecue, and soft drink business called the Ritz. The motel still exists, one of the oldest still in operation today, and has expanded to also include apartments.

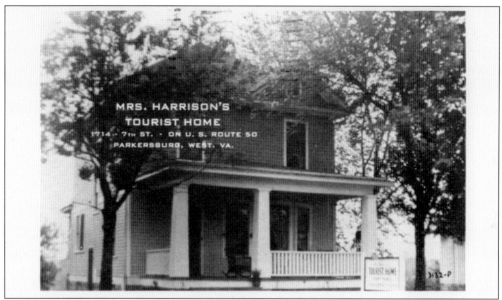

MRS. HARRISON'S TOURIST HOME, C. 1940. Mrs. Jessie V. Harrison (1887–1975) ran a successful tourist home at 1714 East Seventh Street for 35 years. A tourist home is what we call a bed and breakfast today—a private home where traveling guests could stay the night for a fee. Prior to the Depression era, these types of enterprises were known as boardinghouses.

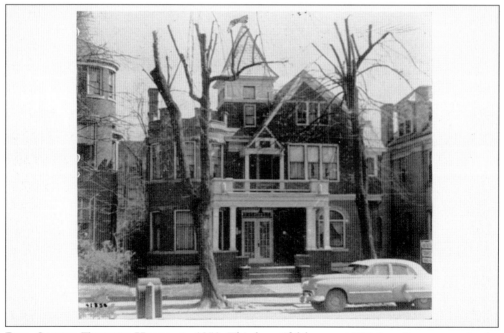

RED CASTLE TOURIST HOME, C. 1950. This beautiful house at 704 Ann Street was—in the 1920s, 1930s, and 1940s—owned by the Rathbone family. By the early 1950s, Mrs. Clara M. Cline resided there and operated the house as a tourist home, calling her enterprise the Red Castle Tourist Home. The structure was purchased by the Camden Clark Memorial Hospital Woman's Auxiliary in 1955 and converted into a clinic and nurses' home. (Courtesy of Dr. John E. Beane.)

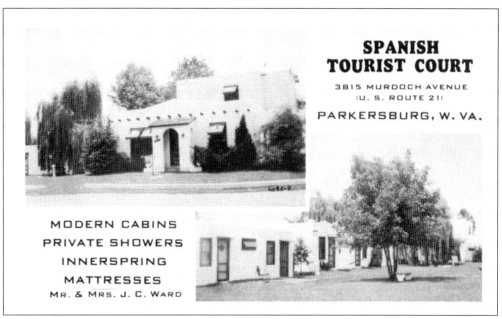

SPANISH TOURIST COURT. This tourist court, predecessor of what we now call a motel, was established in the late 1940s by John Chapman Ward and his wife, Bina. It was located at 3815 Murdoch Avenue, now Grand Central Avenue. It was sold by the Wards in 1954.

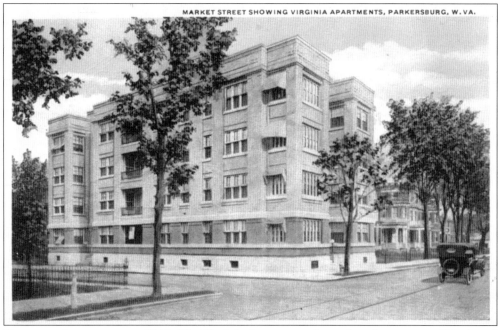

VIRGINIA APARTMENTS, 1916. The Virginia Apartments, located at the corner of Tenth and Market Streets, were constructed in 1916 under the ownership of John J. Crotty. The building contained 16 identical apartments. Each unit was originally supplied with two brass beds in addition to a Murphy bed. This apartment building is still in use today and maintains many of its charming historical features.

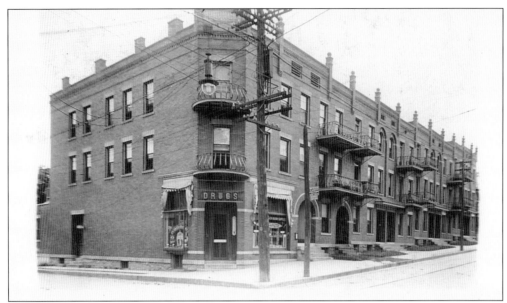

SAVAGE FLATS, C. 1915. The Savage Flats, located at the corner of Thirteenth and Avery Streets, were built in 1903 by Thomas S. Savage. Kramer's Pharmacy, and later Kramer's Photo Supply, was also located in the building. After extensive renovations within the last few years, the building has been re-opened with 23 apartments and is now called the Thirteenth and Avery Street Apartments. (Courtesy of Dr. John E. Beane.)

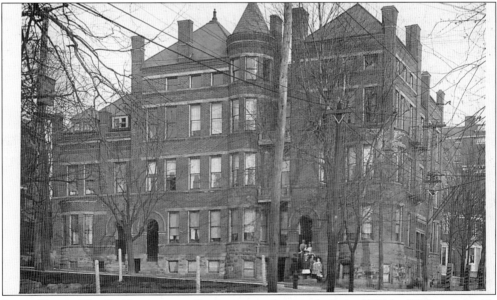

ROBB FLATS. The Robb apartment/business complex was built in 1887 by William J. Robb, originally as housing for single women. It was located at the corner of Eighth and Juliana Streets. The large red brick structure had commercial spaces in the raised basement and first floor and apartment units on the upper floors. At 11 p.m. on September 21, 1987, a fire broke out in one of the upper floors, damaging the top two floors and the attic and destroying the roof. The building was demolished soon afterward. (Courtesy of Dr. John E. Beane.)

Five

DISASTERS

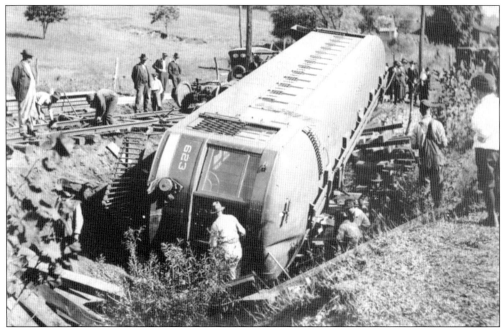

STREETCAR #623 ACCIDENT. On May 1, 1920, Parkersburg streetcar #623 of the Monongahela Valley Traction Company was running a late return trip from Marietta, Ohio, to Parkersburg. On a straight stretch of track near Central, the car hit a mule that was on the track. The impact caused the car to derail and flip into a ravine. The accident site could not be reached by the Baltimore & Ohio wrecker, and the streetcar was hoisted back onto the track by men using logs.

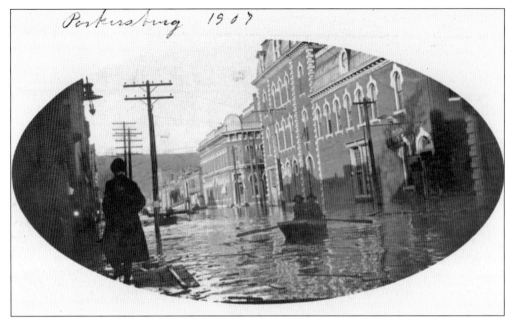

JULIANA STREET, 1907 FLOOD. In March 1907, the Ohio River flooded and crested above flood stage at 51 feet. Damage estimates were between $200,000 and $250,000, the largest loss being suffered by the Parkersburg Iron & Steel Company. The 1907 flood ranks fourth on the list of Parkersburg's worst floods. Shown in this view is Juliana Street looking south toward Fort Boreman Hill. The structure seen on the right is the side of the Prager-Coram-Keltner building, later known as the Pio Tei building. It was demolished in 1981.

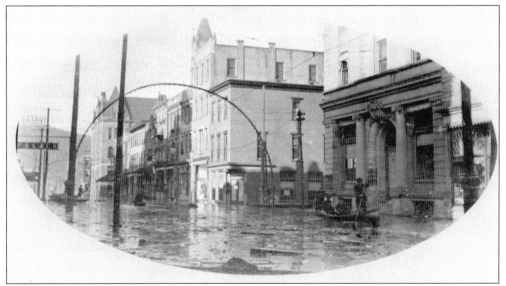

MARKET STREET, 1907 FLOOD. This view shows flooded Market Street at the Fourth Street intersection with a large amount of floating debris. When the water receded, Market Street had several sunken areas in the brick street and along its sidewalks. Barrels of slack lime were purchased by city officials to be thrown on the streets to cover the intense smell. The street commission had a force of men ready with wagons to begin the task of removing the rubble.

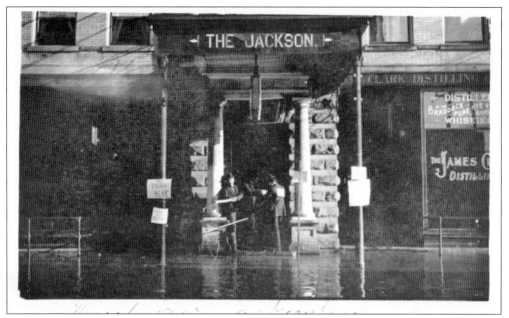

JACKSON HOTEL, 1907 FLOOD. This buff-colored, pressed-brick hotel was located at the corner of Market Street and Court Square. This postcard shows the front of the Jackson Hotel with three unidentified gentlemen displaying their sense of humor. With floodwater up to the entrance, these jokesters have posted "No Fishing" signs on the front posts while pretending to fish.

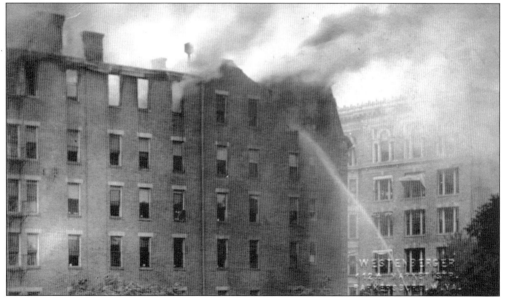

CHANCELLOR HOTEL FIRE, 1911. At noon on August 23, 1911, a fire broke out in a linen room on the top (seventh) floor of the Chancellor Hotel at the rear of the building. Although the building was constructed as "fireproof" and the flames were contained, a gas explosion or some other force caused a large portion of the brick wall to blow outward. Portions of the wall fell onto a nearby physician's office where three teenage boys were killed. (Courtesy of Blennerhassett Island Historical State Park.)

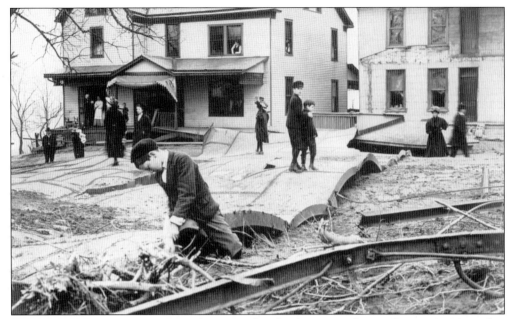

WATER TANK DISASTER, 1909. The City of Parkersburg passed an ordinance in November 1881 to create an organized water system. Two iron and steel tanks were constructed in 1884 on the top of Quincy Hill, establishing the Parkersburg Water Department. On March 19, 1909, the 25-year-old tanks ruptured, sending two million gallons of water down onto Parkersburg. Shown here are the remains of the tanks on Quincy Hill.

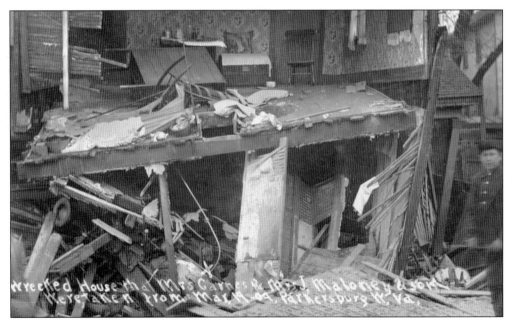

WATER TANK DISASTER, 1909. Located behind St. John's Lutheran Church on Avery Street, this small duplex home was completely destroyed by the rupturing of the water tanks in 1909. Ms. Kate Carnes, an invalid woman from Athens, Ohio, who was temporarily residing in the home, was injured when the structure fell in around her. She died 12 days later of her injuries.

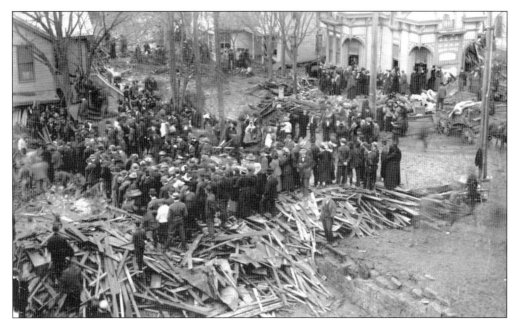

WATER TANK DISASTER, 1909. Two of the victims of the March 19, 1909 water tank disaster were a young plumber and his wife—Walter and Floria (Toncrey) Wigal. Their home, situated halfway up the steep embankment of Quincy Hill, was washed off of its foundation and sent into Avery Street below. It is often written that the Wigals were newlyweds. Although they had not yet started a family, they had been married for several years. This view shows the search for the couple.

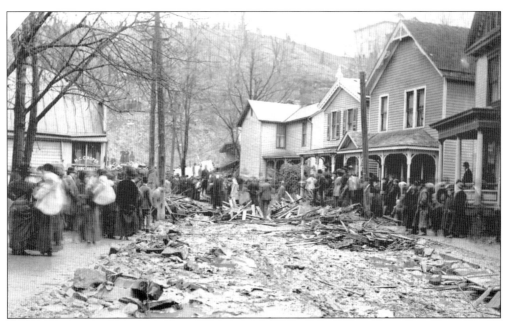

WATER TANK DISASTER, 1909. Tenth Street is shown on this postcard looking toward Quincy Hill after the water tank disaster of March 19, 1909. Nearly everything on the Avery Street side of Quincy Hill was washed into the streets below. Five days were required to remove the debris. It took five years for victims of the disaster to settle their claims with the city.

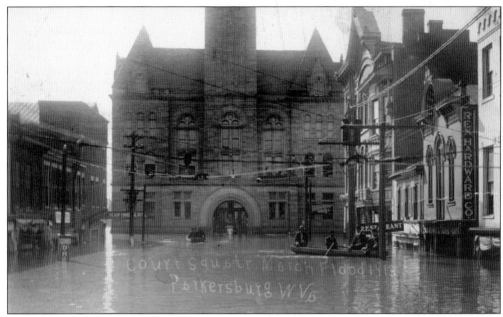

COURT SQUARE, 1913 FLOOD. The worst flood in Parkersburg's history occurred on March 29, 1913, which was caused by nearly four inches of rain falling within a 48-hour period. High water is shown in this postcard view of Court Square. Courthouse records were moved to the Union Trust building at Seventh and Market Streets for safekeeping. Since several buildings collapsed, a group of architects and contractors were hired by the city officials to evaluate the structural integrity of each building affected by the flood.

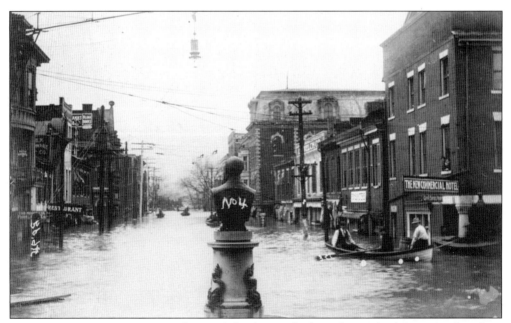

THIRD STREET, 1913 FLOOD. This 1913 flood scene looking down Third Street is taken from the front steps of the Wood County Court House. The back of the Jackson Memorial Fountain can be seen in the center of the postcard.

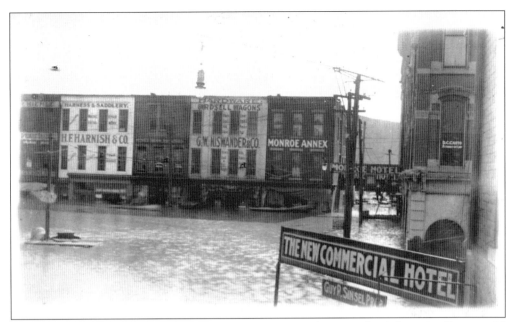

COURT SQUARE, 1913 FLOOD. This view taken during the 1913 flood from the Commercial Hotel shows the southwest corner of Court Square. The following businesses are visible: H.F. Harnish & Co. (harness maker; 234 Court Square), Henry Nern's store (boots and shoes; 232 Court Square), G.W. Niswander (hardware and builders' supplies; 230 Court Square), and the Monroe Hotel Annex (228 Court Square). Despite the high water, most of these businesses were back in operation a week later.

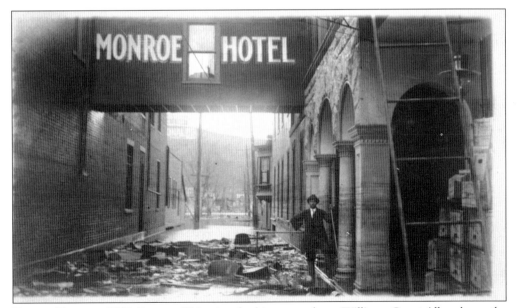

FLOOD DEBRIS, 1913 FLOOD. This view looking west down Williams Court Alley shows the debris left by the 1913 flood. The Monroe Hotel, located on the southwestern corner of Court Square, can be seen on the right. The Monroe Hotel Annex is on the left. There was a covered walkway connecting the two structures.

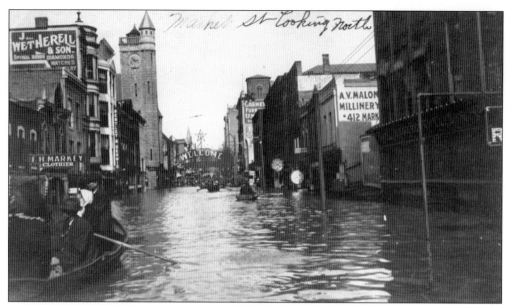

MARKET AT FOURTH STREET, 1913 FLOOD. Herbert R. DeBussey, a cashier at the Central Banking and Security Company, sent this postcard of the 1913 flood to a family member in Sherman, West Virginia. He writes: "Ohio River highest in history 58 9/10 feet. 6 ft. higher than '84. 100's made homeless here. Up Market St. to Dils Bros. Co. Up Juliana to 7th." This photo was taken in front of Robert Taft's Department Store at 404 Market Street.

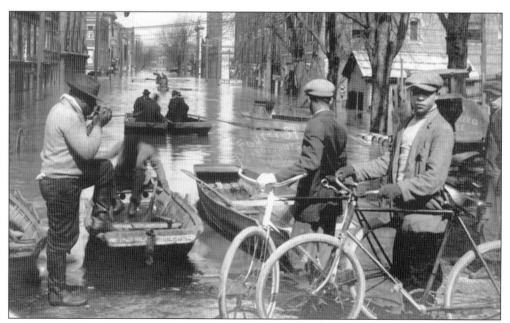

FOURTH STREET, 1913 FLOOD. Skiffs became the primary mode of travel in the downtown section during the 1913 flood. Skiff owners seized the opportunity to make a little money by transporting goods for business owners or stranded citizens. Newspaper accounts report that some skiff owners were charging $1 per hour. The water's edge of Fourth Street is shown here with several skiffs visible.

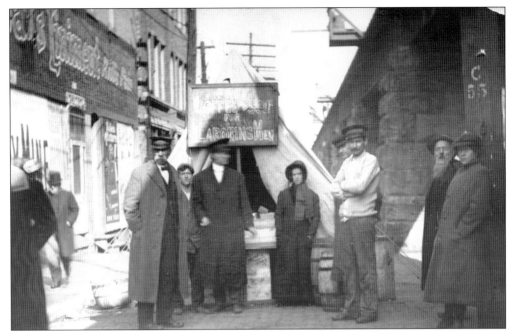

FOOD FOR FLOOD WORKERS, 1913 FLOOD. This tent, set up by the Salvation Army at the corner of Sixth and Market Streets, offered free hot coffee and soup to laborers assisting in the 1913 flood clean-up effort. Fifteen thousand workers were served at this food station. The board of commerce bore the expense. The food was served by members of the Salvation Army.

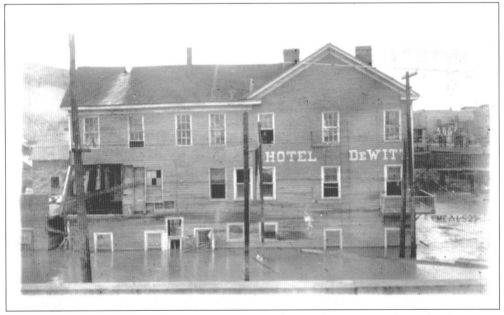

HOTEL DEWITT GAS EXPLOSION, 1913 FLOOD. The Hotel DeWitt was located at the corner of Second and Ann Streets, close to the Ohio River Railroad Ann Street Depot. During the 1913 flood, on Thursday, March 27, an explosion of gas in the hotel blew out the rear portion of the building. Note that the rear chimney was also blown out.

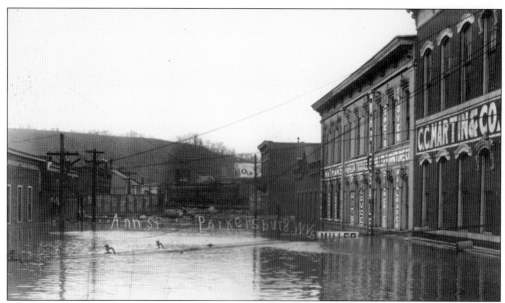

ANN STREET, 1913 FLOOD. This view shows high water on lower Ann Street as viewed looking south toward Fort Boreman Hill. The Little Kanawha Railroad Bridge is shown with a stranded train waiting for the water to recede. The Nathan Clothing Company, Amicon Produce, Miller Furniture, and C.C. Martin Wholesale buildings, all shown to the right, were completely destroyed by fire a few days later.

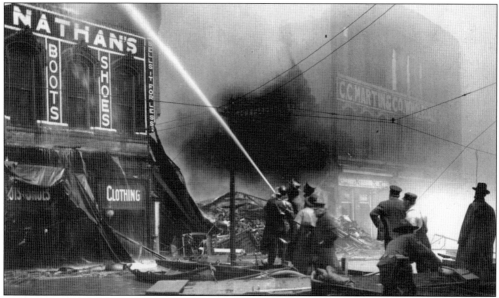

C.C. MARTIN FIRE, 1913 FLOOD. On Tuesday, April 1, 1913, just after the waters of the devastating flood began to recede, another disastrous event occurred. Fire broke out in the C.C. Martin Wholesale House at the southwest corner of Third and Ann Streets. The intensity of the fire threatened the entire lower end of the city. The Miller's Furniture building, located next door, collapsed. Nathan's Clothing store at 225 Ann Street suffered the least damage because of a strong firewall along the side of the building.

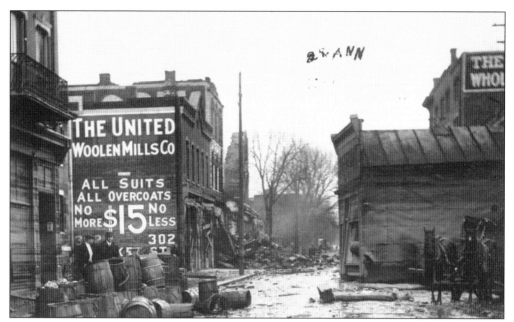

FIRE RUINS, 1913 FLOOD. The ruins of the April 1, 1913 fire can be seen looking north on Ann Street from Second toward Third Street. The fire was so brutal that, had it not been contained, plans were already laid out to dynamite surrounding structures in order to stop the fire from spreading.

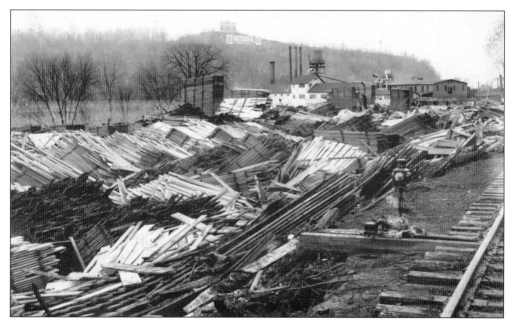

PARKERSBURG MILL, 1913 FLOOD. Parkersburg Mill's once neatly stacked piles of lumber were tumbled by the 1913 floodwaters. The Parkersburg Mill, started in 1858 at Third and Green Streets, later moved to Second and Avery Streets. In 1920, the mill ceased the processing of timber and became a building supply center. The mill site was demolished in 1994 to build the Bureau of Public Debt's H.J. Hintgen building.

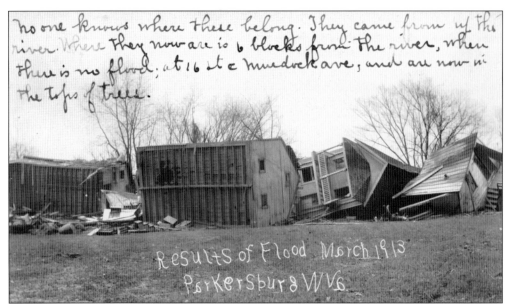

DISPLACED HOUSES, 1913 FLOOD. An estimated 150 wooden structures were lifted from their foundations during the 1913 flood and floated down the river. The handwritten caption on this postcard reads, "No one knows where these belong. They came from up the river. Where they now are is 6 blocks from the river, where there is no flood; at 16th & Murdoch Ave., and are now in the tops of trees."

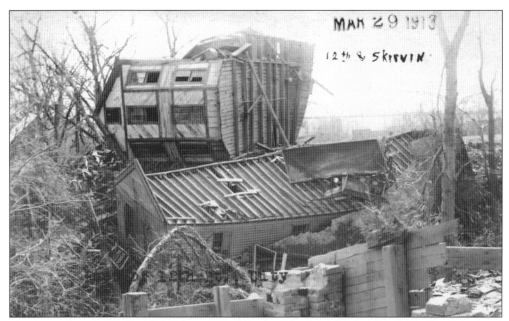

TWELFTH AND SKIRVEN STREETS, 1913 FLOOD. The hardest hit areas from the 1913 flood were the Riverside and Beechwood sections of Parkersburg. Within the tangle of buildings, the remains of a building's foundation can be seen. A house on Twelfth and Skirven Streets landed perfectly upside down and became a popular curiosity for sightseers. (Courtesy of Wood County Historical and Preservation Society.)

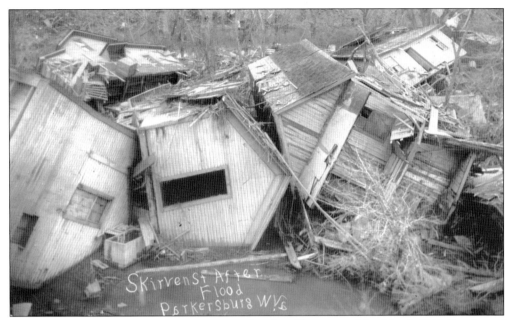

SKIRVEN STREET, 1913 FLOOD. Here is another horrific scene of the March 1913 flooding of Parkersburg. Complete buildings toppled about and came to rest upon once peaceful lawns. It would take months of hard work to put these areas back into order.

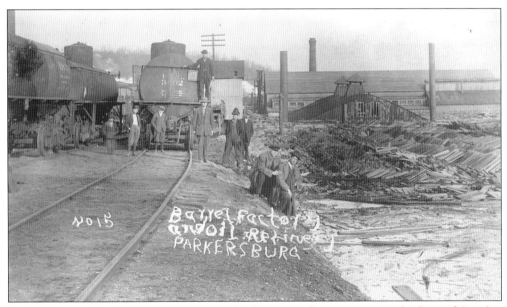

BARREL FACTORY, 1913 FLOOD. The Parkersburg Barrel Factory was a subsidiary of Camden Consolidated Oil Company Refinery (later known as Standard Oil Company Refinery) and was essential in providing barrels for shipping and storage purposes. The factory employed many men and boys, some as young as 14 years of age. The factory would also purchase oak barrel staves from local farmers who made them on their farms during fall and winter for extra income. This view shows the barrel factory and oil refinery shortly after the 1913 flood. (Courtesy of Dr. John E. Beane.)

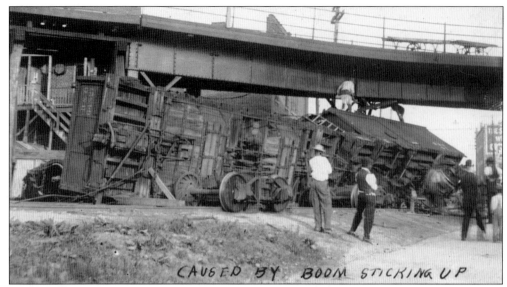

STEAM SHOVEL INCIDENT. On June 27, 1913, an incident occurred that resulted in two cars from a freight train overturning on the Ohio River railroad transfer track on Second Street. The train was transporting a large steam shovel in one of its cars. Unfortunately there was a miscalculation of its height, and when the train went under the railroad viaduct, the boom sticking up did not clear the beam above. The force was so great that not only did the cars overturn, but they also were pulled apart from the rest of the train, and two of the viaduct support beams were torn out. (Courtesy of Wood County Historical and Preservation Society.)

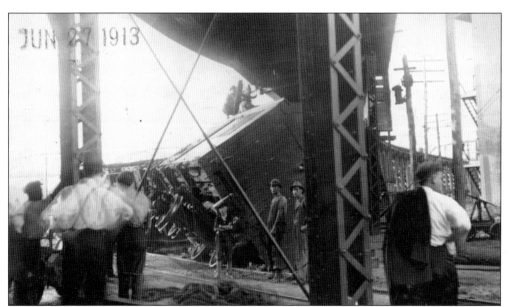

STEAM SHOVEL INCIDENT. Onlookers quickly gathered at the site of the overturned freight cars. Within hours, the wreckage had been cleared away and work began on supporting the damaged viaduct. An unknown man who had been sitting under the viaduct narrowly escaped death as he quickly moved away when he saw the steam shovel plunge down towards him. (Courtesy of Wood County Historical and Preservation Society.)

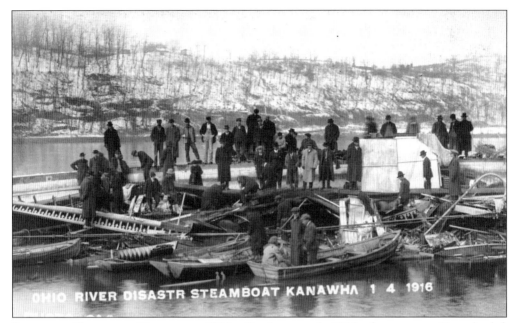

STEAMER *KANAWHA* DISASTER, 1916. On January 4, 1916, the steamer *Kanawha* left Parkersburg just before 7 p.m. on its way to Little Hocking, Ohio. Upon reaching Little Hocking, the steamboat unloaded its cargo and began backing into the river. The water was high and Lock #19 was submerged. The steamboat *Kanawha* struck a light tower at the edge of the lock wall. A large hole was torn in the starboard side of the boat. It only took about three minutes for the steamboat to capsize. It did not completely sink and began floating down the Ohio River.

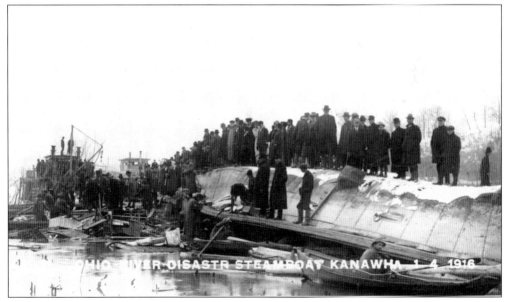

STEAMER *KANAWHA* DISASTER, 1916. News reached Parkersburg about 8:30 p.m. of the steamboat *Kanawha* disaster. Capt. Ernest Chapman of the Ohio River division of the Baltimore & Ohio dispatched a relief train to pick up survivors. The overturned steamboat finally came to rest just after 9 p.m. As feared, 16 people perished in the accident.

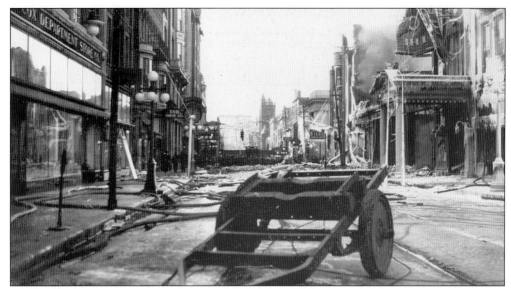

CAMDEN THEATER FIRE. At 7:30 p.m. on the extremely cold evening of November 30, 1929, a fire broke out beneath the stage of the Camden Theater. Within three hours, the entire city block between Seventh and Eighth Streets was ablaze. All of the city's fire equipment and many volunteers were engaged in the firefighting effort, but by midnight, most of the businesses in the block were reduced to ruins. This postcard view is looking south on Market Street with the Camden Theater ruins on the right side.

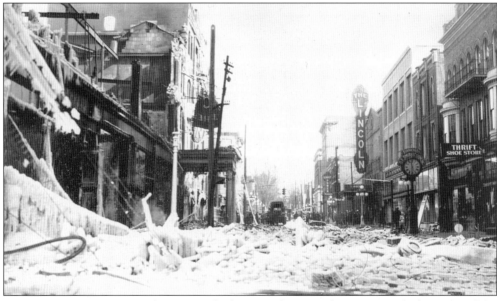

CAMDEN THEATER FIRE. This view is looking north on Market Street with the ruins of the Woolworth 5 and 10 store on the left, followed by that of the Camden Theater. Ice-covered bricks, fire hoses, and other debris cover the street. The losses were staggering and included the Julian Goldman Clothing Store, the Wun-der Shoe Store, the four-story Mullins Building, the Mountain State Business College, numerous doctor's offices, insurance agencies, the Elsie Janis Hat Shop, the Ira Congrove Shoe Shop, the Dutch Oven, and many more.

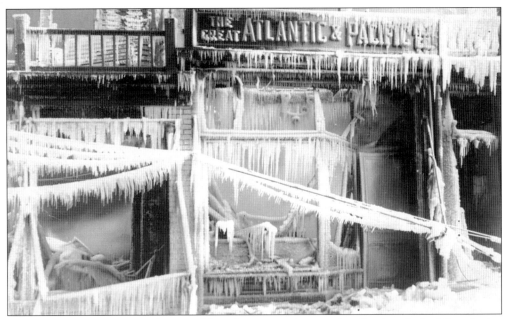

THE GREAT ATLANTIC & PACIFIC TEA COMPANY. As a result of hosing the building during the Camden Theater fire in such freezing conditions—a reported 10 degrees—a fascinating array of icicles covered all that remained. Water from the fire hoses froze as quickly as it fell, coating the structures and streets in ice. The storefront shown, the Great Atlantic & Pacific Tea Company, was located at 715 Market Street.

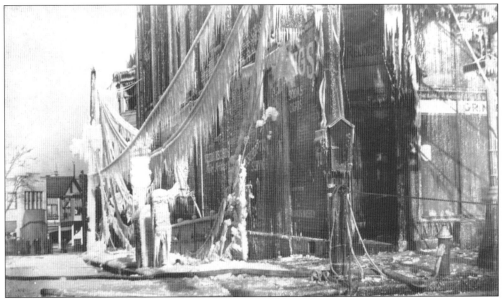

GRINTER DRUG STORE. Shown here the day following the big Camden Theater fire is the ice-encrusted Grinter Drug Store at the northwest corner of Seventh and Market Streets. The drug store, the apartments above it, and many small shops and business extending along the north side of Seventh Street were all destroyed. Due to the firefighting efforts, a coating of ice three to six inches thick formed on Seventh Street. Boy Scouts helped to spread sand and salt onto the icy streets.

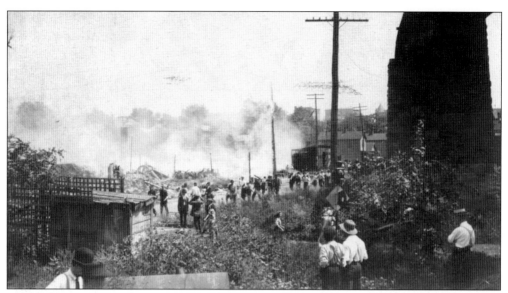

PARKERSBURG ICE COMPANY FIRE, 1908. At 11:45 a.m. on August 12, 1908, Parkersburg experienced one of its worst fires. The fire originated in the engine room of the newly established Radeker Lumber Company's mill, formally the West Virginia Veneer & Door Company property, located at the west end of Sixth Street. The fire spread quickly and soon also engulfed the large establishment of the Parkersburg Ice Company. Both of these companies were destroyed. The heat was so severe that it threatened the Baltimore & Ohio Railroad Bridge that passed above.

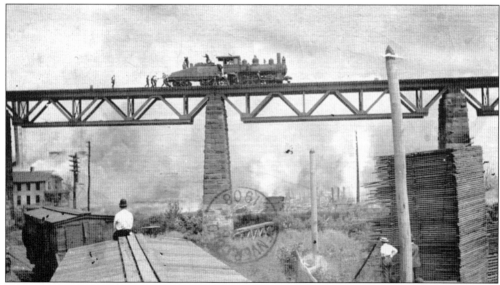

FIRE DISASTER, 1908. Factors that caused the Parkersburg Ice Company fire to get out of control were a lack of available water and the exhaustion faced by the fire department. To protect their own interest, the Baltimore & Ohio Railroad Company sent an engine out onto the Sixth Street Bridge loaded with water to help with the effort. Additionally, ten homes, the majority on Monroe Street in close proximity to the ice plant, were destroyed. This postcard, sent by Lizzie Vaughan of Parkersburg, states that in this picture her house is on fire.

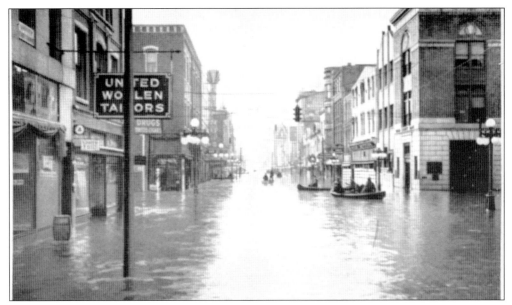

MARKET STREET, 1937 FLOOD. The second worst flood in Parkersburg's history occurred in January 1937. This flood was caused by 13 consecutive days of rain and snow. The wintry mix pushed the Ohio River to a level of 55 feet and 4 inches. After the floodwaters receded, the fire department hosed off streets, and the Works Progress Administration workers pumped out cellars. Shown here is the intersection of Market and Fifth Streets looking south.

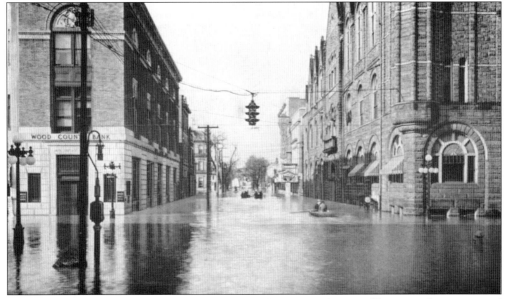

FIFTH STREET, 1937 FLOOD. This view is looking west down Fifth Street showing Wood County Bank, the Parkersburg City Building, and the Smoot Theater during the January 1937 flood. Since the boiler room of the city building was flooded, the police department and city officials had to conduct relief efforts without heat. Adjacent to the city building's boiler room was a battery room that powered the city's traffic lights. Traffic lights all over the city went dark, causing problems at busy intersections.

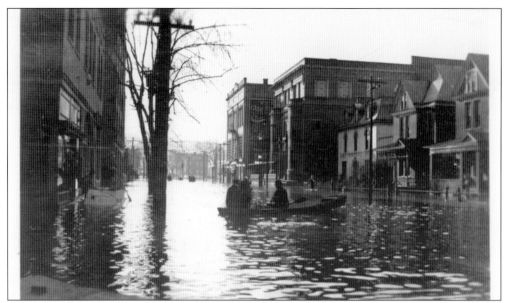

BOATING UP JULIANA STREET, 1937 FLOOD. Automobiles and streetcars were replaced with boats as the mode of travel in the 500 block of Juliana Street during the 1937 flood. Streetcar service continued to areas of the south side but was disrupted in downtown Parkersburg and Marietta. Shown in this postcard, on the left, are the Elk's Club, Parkersburg Sentinel, and Case Manufacturing Company. (Courtesy of Blennerhassett Island Historical State Park.)

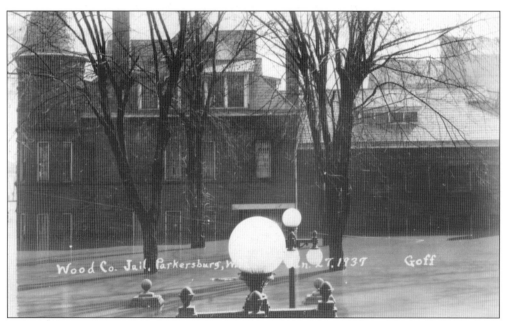

WOOD COUNTY JAIL, 1937 FLOOD. Just before the flood, two fugitives who were suspected in a holdup of an ice-cream store at Mary and William Streets were apprehended. The Parkersburg police locked the two men in the city jail, then located in the basement of the city building. The water flooded the city building, and the men were transported to the Wood County Jail. Soon after, the high water reached the county jail, and the prisoners were once again moved.

Six
PARKS AND SPECIAL EVENTS

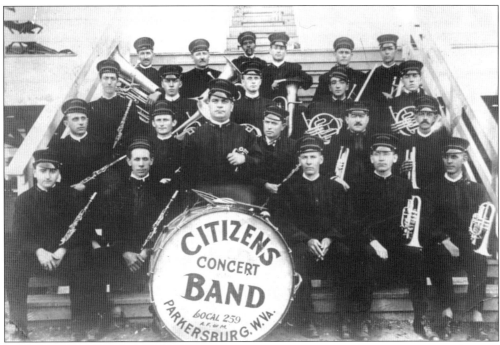

CITIZENS CONCERT BAND. The Citizens Concert Band was a familiar site in town performing at parks, fraternal organization's event, and in parades. They were established as the Lauckport Band in 1884, renamed Citizens Band in 1895, organized under the Local 259 of the American Federation of Musicians, and were supported by the City of Parkersburg through municipal taxes. They represented the best of local musical talent. Over the years, the band was directed by J.C. Arnold, Frank Treadway, George Dietz, Frank Schroeder, and others. The popularity of this type of entertainment severely declined shortly after World War II. The group disbanded in the summer of 1961.

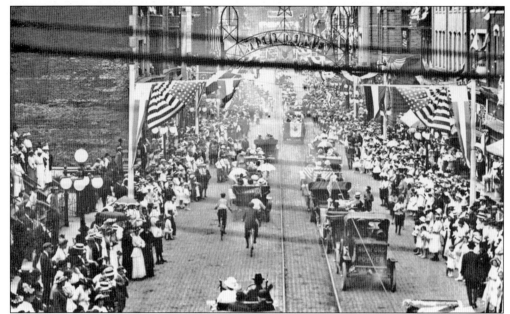

PARKERSBURG CENTENNIAL PARADE. The most spectacular feature during the Parkersburg Centennial week of events, September 5–10, 1910, was "The Fantastic Parade." Between 400 and 500 people donned their parade finery and marched about downtown streets. This view, taken from the Sixth Street Baltimore & Ohio Railroad Bridge, is of the parade procession moving south toward Fifth Street.

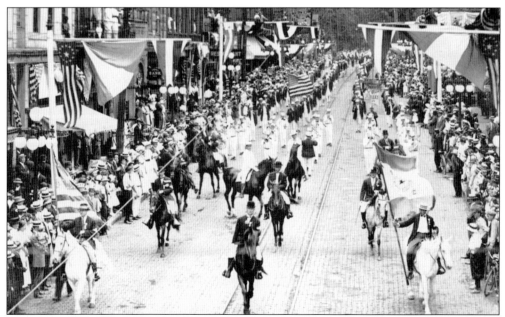

THE FANTASTIC PARADE. This is another view of the Parkersburg Centennial parade taken from the Sixth Street Baltimore & Ohio Railroad Bridge looking north. The storefronts were elaborately decorated with flags and colorful buntings. Paul Lehman was the grand marshal and was mounted on a horse for the event.

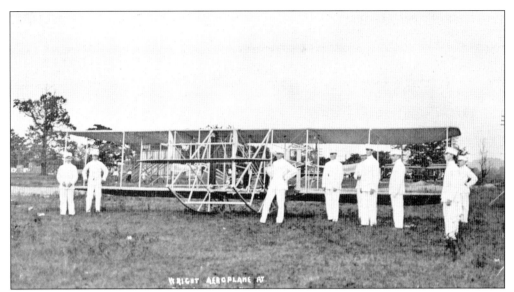

WRIGHT BROTHERS' AIRPLANE. During the 1910 Parkersburg centennial, the original 1903 Wright brothers' airplane was brought here at a cost of $5,000. Piloted by T.O. Parmalee, the airplane was commissioned for a series of aviation feats. One particular event was a five-mile race at Shattuck Park between an automobile driven by J.M. Jackson Jr. and the airplane. The airplane won, beating the automobile by a small margin.

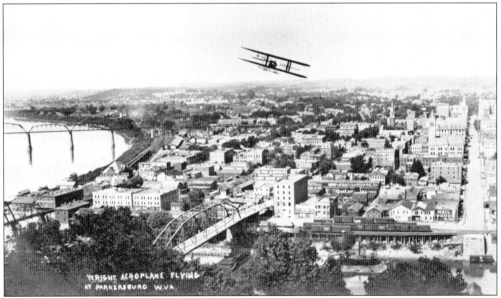

WRIGHT BROTHERS' AIRPLANE FLYING OVER PARKERSBURG. A very interesting and popular postcard for the 1910 celebration was this one showing the Wright airplane flying over Parkersburg. It has long been a topic of controversy whether photographer H.P. Fisher faked this photograph or not by superimposing the image of the plane over an existing panorama of the city. The Wright brothers' plane returned to Parkersburg on another occasion. During that visit in August 1913, the plane crashed into the City Park pond. (Courtesy of Blennerhassett Island Historical State Park.)

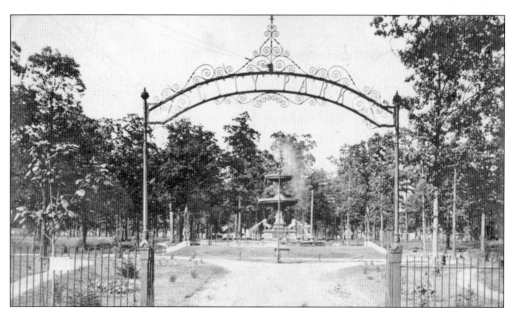

ENTRANCE TO CITY PARK, 1907. In 1887, 40 acres of the Oakwood section of Parkersburg was purchased by five local merchants to create an agricultural and recreational park called City Park. The City of Parkersburg purchased the park in 1896 for $20,000. An additional four acres was added in 1906 to create the entrance shown here. Visible in this postcard is the Jackson Memorial Fountain and the ornate wrought-iron entrance gate. (Courtesy of Wood County Historical and Preservation Society.)

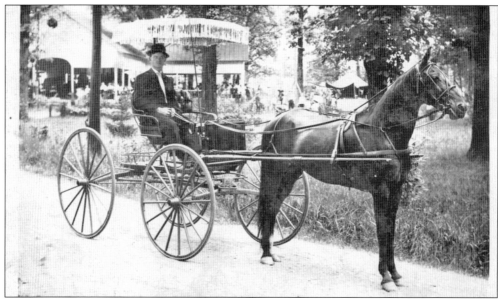

HORTICULTURAL HALL. Henry Clay Neale sits in his buggy with his favorite race horse "Shookum G." at Parkersburg's City Park. The large building in the background is the pavilion, built as a horticultural hall when the park grounds belonged to the Wood County Agricultural and Mechanical Fairground Association. In 1925, the pavilion was replaced with an upgraded brick structure, designed by architect Harry R. Nay and named the Ahrendt Memorial Pavilion.

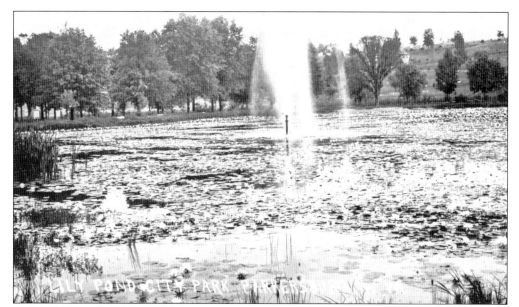

LILY POND. The City Park lily pond was artificially created in the area of the old park bicycle track, covering approximately two acres. In 1907, Andrew D. Hopkins of Mineral Wells donated lotus lilies for the pond. During its heyday, the pond was recognized as the largest lily pond in the United States. In the late 1970s, the lake was made over. The lilies were removed and docks were added to provide paddleboat rentals. A modernistic sculpture called *Wings of Progress* was placed in the center. Park patrons also enjoyed two beautiful swans, ice-skating, and fishing. (Courtesy of Blennerhassett Island Historical State Park.)

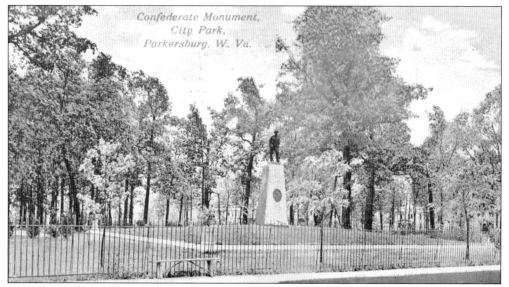

CONFEDERATE MONUMENT. This postcard shows the area of the Confederate Monument in the City Park. The monument was erected by the Parkersburg Chapter #385 of the United Daughters of the Confederacy in 1908 in honor of the Confederate dead. The base of the monument is Vermont granite and is topped with a spectacular 7-foot-tall bronze statue of a Confederate soldier. The monument weighs 23 tons and originally cost $2,311.

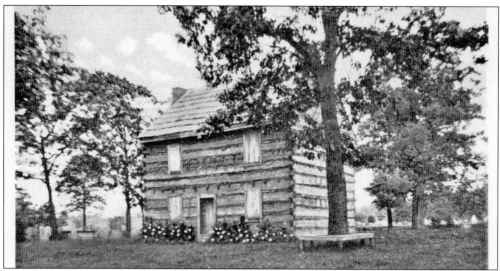

HENRY COOPER LOG CABIN MUSEUM. The Centennial Chapter of the Daughters of American Pioneers (DAP) was created in 1899. Part of the aim and purpose of the society is to collect and preserve heirlooms and relics of pioneers. In 1911, the Daughters were granted use of the two-story Henry Cooper log house in the City Park to house their growing museum collection. The structure, originally part of Henry Cooper's several-hundred-acre estate on Elizabeth Pike near Mineral Wells, was purchased in 1910 by the city and moved to the park to preserve it as a specimen of an early pioneer homestead. It is still maintained by the DAP as a museum. (Courtesy of Blennerhassett Island Historical State Park.)

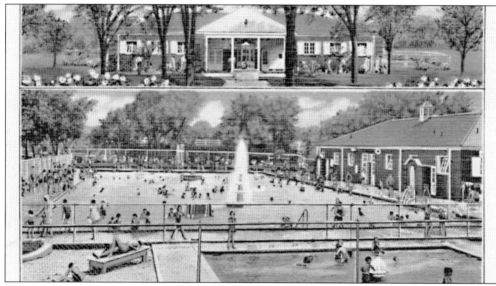

CITY PARK SWIMMING POOL. The Parkersburg Municipal Swimming Pool officially opened in the summer of 1936 at the northeastern corner of the City Park. It was funded through WPA funds and city bonds. The pool measured 75 feet wide by 164 feet long, had a water capacity of 420,000 gallons, and could accommodate up to 750 swimmers at a time. A 20-feet-by-30-feet kiddie-size pool, large lounge deck, and sand beach were also provided. The brick bathhouse is American Colonial in style and measures 24 feet by 96 feet. The pool and bathhouse are still in use.

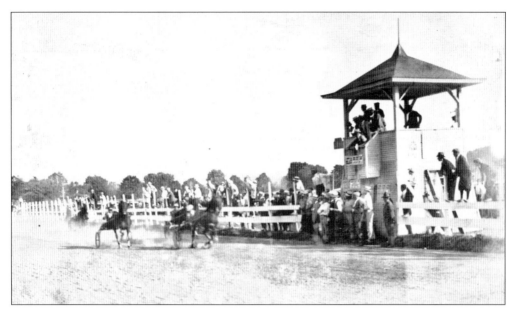

BICKEL ESTATE RACETRACK, C. 1930. This is the racetrack and judge's stand at the William H. "Wig" Bickel estate during an undated harness race. The judge's box protruded out of the front of the judge's stand to give the judge an unobstructed view of the action. The horses were correctly lined up at the starting line by the use of a fixed overhead wire as a visual guide. There was a bell suspended from the peak of the stand's roof that would be rung in the case of a bad start.

SHATTUCK PARK GRANDSTAND, C. 1908. This grandstand was situated along the one-half-mile horseracing track at the West Virginia Fairgrounds, located on Broadway Avenue in south Parkersburg. The 65-acre fairground was called Shattuck Park in honor of Charles Horace Shattuck. The structure could hold 4,500 spectators. Admission was 25¢. Underneath the grandstand were refreshment stands, the bookmaker's counter, and miscellaneous offices. (Courtesy of Dr. John E. Beane.)

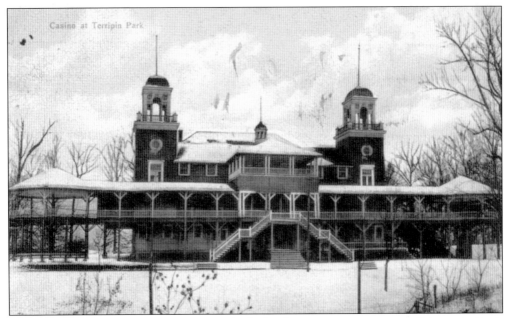

TERRAPIN PARK CASINO. In January 1898, the local streetcar company awarded a contract to erect a massive auditorium at a newly created park. The building, called the Terrapin Park Casino, cost $15,000 to build and measured 200 feet across the front. It remained a main fixture of the park until August 28, 1917, when it was consumed by a mysterious fire.

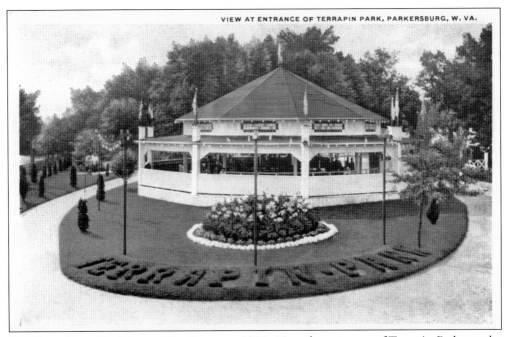

HE HAW–HAW HE MERRY-GO-ROUND, 1916. Near the entrance of Terrapin Park stood a building that housed the merry-go-round made by the Allan Herschell Carrousel Company of North Tonawanda, New York. This $3,000 attraction was purchased and installed in 1913. The merry-go-round was sold after the Terrapin Park Casino fire.

TERRAPIN PARK LAKE, 1916. A small stream called Spring Creek was dammed in October 1898 to create the Terrapin Park Lake. Boating, ice-skating, and, at times, swimming were enjoyed at the lake. During the declining years of the park in the late 1910s, the lake was deemed unsafe, and the man-made dam was broken and the water drained.

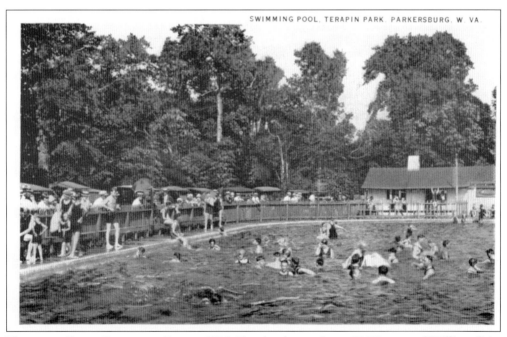

TERRAPIN PARK SWIMMING POOL, 1924. Two local men, James H. Watson and William Cain, constructed this teardrop-shaped swimming pool in 1922. The water was purified by a process known as ultraviolet ray sterilization. A drowning accident in 1934 and competition from City Park Pool marked the beginning of the end for the pool.

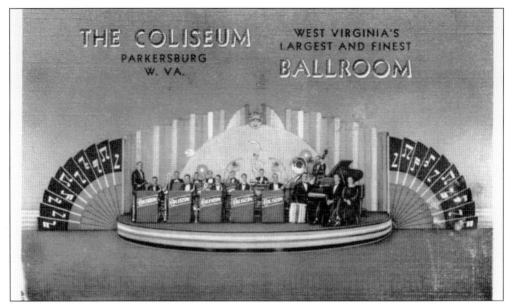

Coliseum Ballroom, 1934. The Coliseum Ballroom was situated on the second floor of the current Warner Pontiac Garage building on Seventh Street. The coliseum was developed in the 1930s by Mr. Sherman Dils in order to diversify his business ventures during the trying Depression years. Band music was featured every weekend. The writer of this postcard states that he spends his weekends here "dancing to exotic rhythms, wearing fancy Latin tuxedos, patent leather shoes, melon cologne, and pommade."

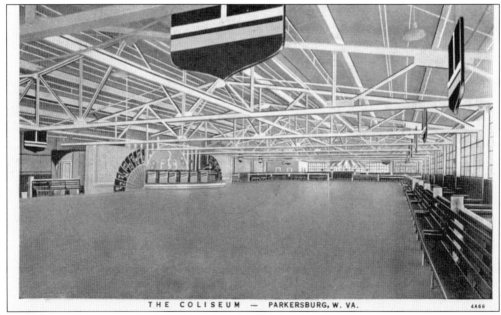

Coliseum Ballroom, 1934. The dance floor for this 18,000-square-foot ballroom was specially designed for its purpose and fitted with Canadian wood. On the far side of the floor was the revolving bar, a one-of-a-kind novelty powered with a Ford Model T motor. The coliseum was later converted into a roller rink, and a bowling alley was installed on the lower floor.

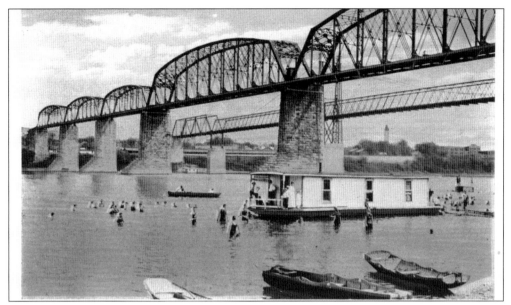

PAR-BEL BATHING BEACH, 1916. In the spring of 1915, a group of local businessmen created a spot on the Belpre side of the Ohio River as a bathing beach. For a publicity stunt, a contest was held in Parkersburg in April 1915 to select a name for the beach. Many different names were submitted, such as "The Willows," "Coronada," "Pleasure," "Sea-More," "Yander," and "Idora." The winning name was picked by Mayor Allen C. Murdoch—"Par-Bel," a contraction for Parkersburg and Belpre.

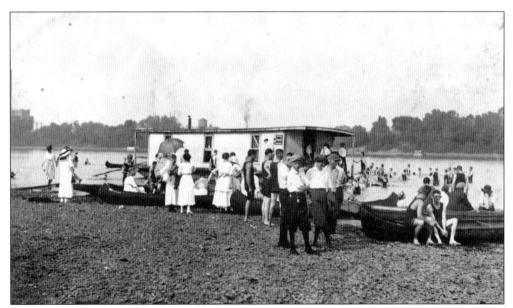

PAR-BEL BATHING BEACH. A necessity for any swimming location is a place for patrons to change their clothing. A 125-foot barge was purchased in Pittsburgh and brought to the Par-Bel Bathing Beach by the steamboat *Clarence*. Contractor Bob Brown was hired to build a bathhouse on the newly purchased barge. The Par-Bel Bath House, shown in the center of this postcard, could accommodate 100 patrons at a time.

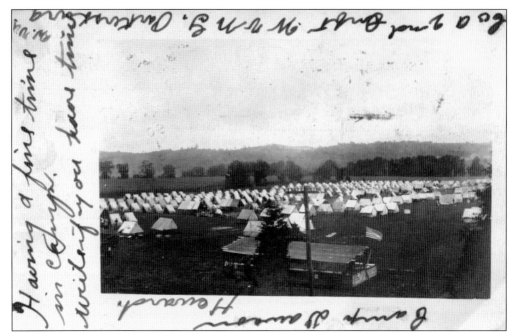

CAMP DAWSON, 1905. The West Virginia National Guard was organized in 1887 with one regiment. The early years of the group were disorganized, but by the 1890s, laws strengthened and defined the organization. In 1891, training camps called encampments were started. The encampment for 1905 was located at Stephenson's Field and was called Camp Dawson in honor of then West Virginia governor William M.O. Dawson.

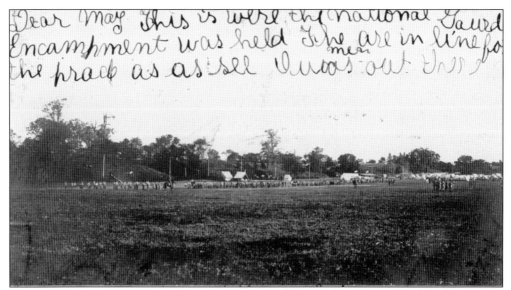

CAMP DAWSON, 1905. Every day during the 1905 West Virginia National Guard encampment at Stephenson's Field, crowds gathered to watch the rifle contests and marching drills. Local photographer C.R. Kerr pitched a tent at the event and began selling photographic souvenirs such as the postcard shown here. The area of Stephenson's Field is now part of the car dealerships on Seventh Street.

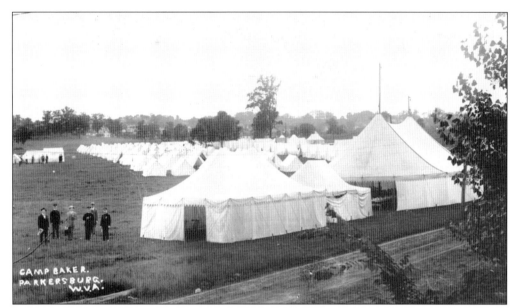

CAMP BAKER. From September 6 through 11, 1909, Parkersburg's Stephenson's Field was the site of the First Annual Encampment of the West Virginia Brigade Uniform Rank Knights of Pythias. The Order of the Knights of Pythias, founded in 1864, is an international non-sectarian fraternal organization. Camp Baker, named for Capt. Samuel B. Baker, drillmaster for Parkersburg Company #3, consisted of well over 150 tents.

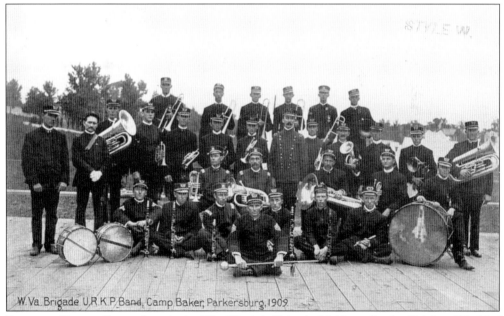

BRIGADE BAND. Shown here is the West Virginia Brigade Uniform Ranks Knight of Pythias' official band, which performed at the Parkersburg encampment named Camp Baker in 1909. About a week prior to the start of the encampment, laborers were busy preparing Stephenson's Field for the big event by setting up the tents and this special platform for band concerts and vaudeville performances. (Courtesy of Dr. John E. Beane.)

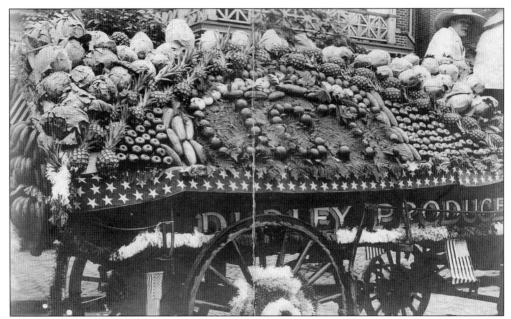

PRODUCE ON PARADE. Pineapples, apples, bananas—a fine selection of the goods available at Dudley's Produce decorates their mule-drawn wagon float created for the United Commercial Travelers' (U.C.T.) Grand Council Convention parade held on May 15, 1908. Trolley rides, boat rides, dances, and baseball games were some of the other events scheduled to entertain the U.C.T. during their three-day conference in Parkersburg. (Courtesy of Dr. John E. Beane.)

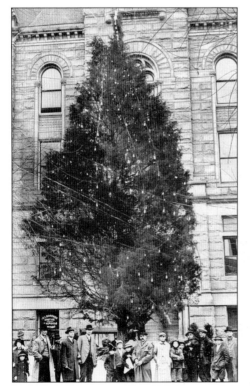

CITY CHRISTMAS TREE. This is the official city Christmas tree for 1913, as displayed at the rear of the Wood County Court House. The tree was decorated with 300 electric lights by the employees of the local streetcar company. An official ceremony was held to mark the event and featured a choir of 50 men. (Courtesy of Dr. John E. Beane.)

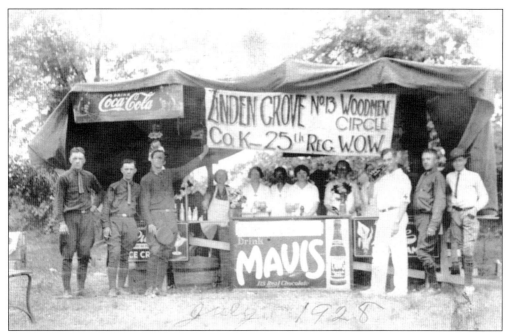

WOODMEN OF THE WORLD, 1928. The newly formed Linden Grove Circle No. 13 of the Woodmen of the World is shown at an encampment at City Park in July 1928. This district encampment, called Camp Enright, was named in honor of Parkersburg lodge member E.M. Enright. Nearly 350 members of the Woodmen of the World, the first fraternal benefit society of the United States, were in attendance.

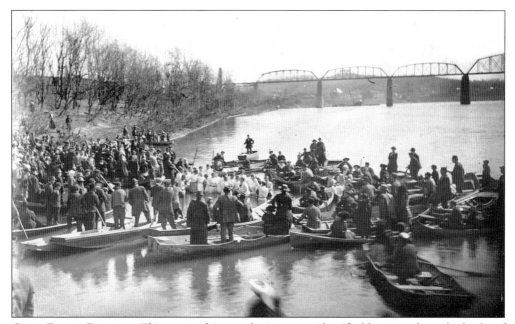

OHIO RIVER BAPTISM. This postcard image depicts an unidentified baptism along the banks of the Ohio River. The Baltimore & Ohio Railroad Bridge is visible in the background. (Courtesy of Dr. John E. Beane.)

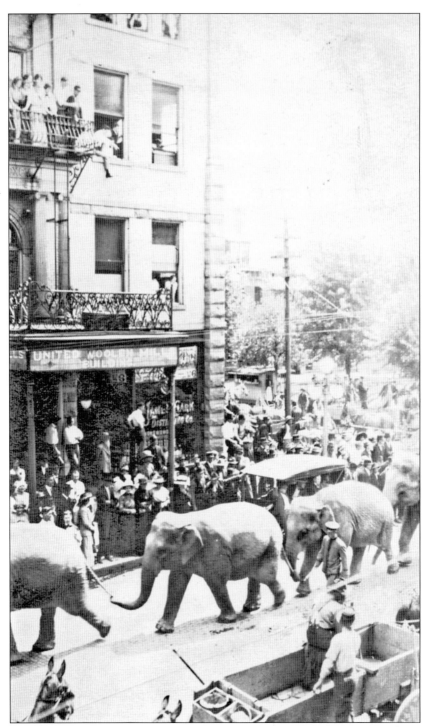

ELEPHANTS ON PARADE, C. 1912. Here, elephants march up Market Street to a destination in town where they could perform, possibly Stephenson's Field. These pachyderm performers were probably transported to Parkersburg by rail, arriving at nearby Ann Street Station. The United Woolen Mills building in the background was located at 300 Market Street.

Seven
CHURCHES AND SCHOOLS

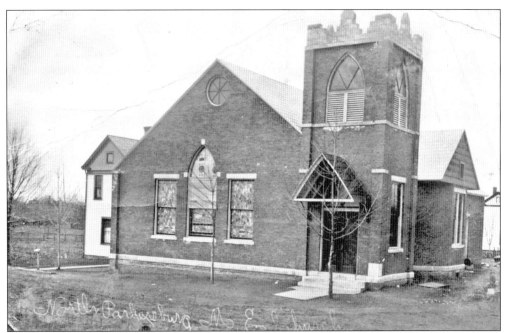

PHELPS CHAPEL, C. 1920. The North End Parkersburg Methodist Episcopal Church, located at 3609 Emerson Avenue, was constructed in 1913 after the congregation outgrew their small one-room Sand Plains Methodist Episcopal Church. This new brick church was dedicated in 1914 as Phelps Chapel. During the late 1940s and early 1950s, the membership once again determined that a larger facility was needed. In 1954, druggist O.J. Stout provided the necessary property, and a new church, Stout Memorial United Methodist Church, was established at the corner of Thirty-fourth and Broad Streets.

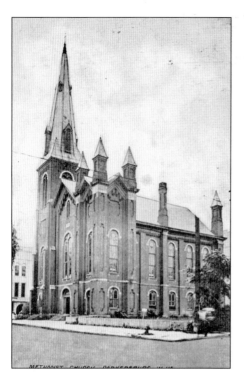

"OLD" FIRST METHODIST CHURCH. One of the earliest Methodist churches in Parkersburg, Monroe Church, was located at Fifth and Juliana Streets. A devastating fire occurred March 13, 1873, that completely destroyed the building. A replacement structure, this spectacular brick Gothic cathedral-like church, was dedicated in 1877. This building served the congregation until 1911 when the First Methodist Church was built at the corner of Tenth and Juliana Streets. The old church building was unused for years, and in 1915, the site was sold to build a furniture store.

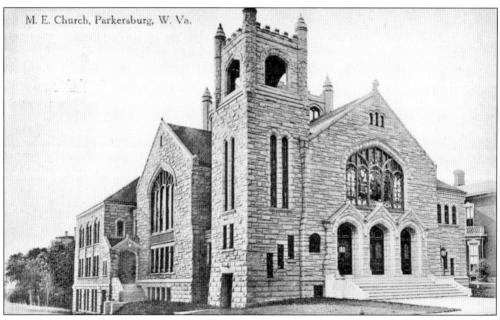

FIRST METHODIST CHURCH. In 1904, the congregation of the old First Methodist Church on Fifth and Juliana Streets decided to leave the downtown location and build a new building in a more residential location. Property was found and purchased at Tenth and Juliana Streets. Plans were prepared by George W. Kramer of New York for a Gothic-style building using light-colored Ohio limestone. It took nearly two years to complete. On January 22, 1911, the congregation met at the old church and walked the five blocks to their new building.

ST. PAUL'S METHODIST CHURCH, 1907. This brick-and-stone structure of St. Paul's Methodist Church South is located at Eleventh and Market Streets. The building was dedicated on July 7, 1901, by Bishop H.C. Morrison of Louisville, Kentucky. Nearly 2,000 people attended the dedication. By the early part of 1950, the bell tower and steeple were declared unsafe. The steeple was removed and capped. In 1992, the congregation spent $25,000 to erect the current steeple.

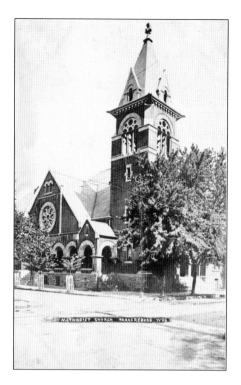

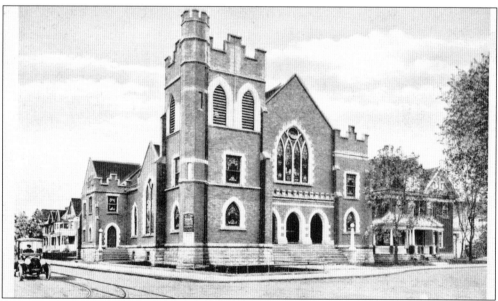

ST. ANDREWS CHURCH, 1916. The congregation of the Elberon Methodist Church outgrew their original quarters at Nineteenth Street and St. Mary's Avenue and had local architect William Howe Patton design this Gothic Revival church with high crenelated towers. Dedicated on March 14, 1909, the name was changed to St. Andrews Methodist Episcopal Church. In March 1922, the members of the church purchased a huge illuminated revolving cross, which was attached 20 feet above the church steeple. It remained a popular feature for several decades. (Courtesy of Blennerhassett Island Historical State Park.)

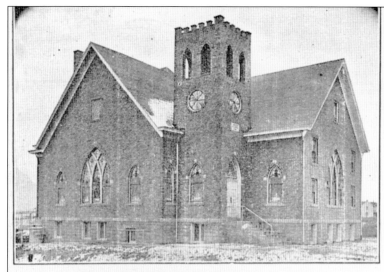

LAUCKPORT METHODIST EPISCOPAL CHURCH
R. L. MANESS, Pastor

Erected at a Cost of Approximately $16000.00

Dedicated January 26, 1919

LAUCKPORT METHODIST EPISCOPAL CHURCH, 1919. A group of Methodist followers on the south side of Parkersburg organized and built a wooden church at 1304 Main Street (now Camden Avenue) from 1879 to 1880. Plans were later formed for a more permanent structure, and on April 2, 1918, ground was broken for the church shown in this postcard. This brick building is still used by the congregation and is located at 908 Camden Avenue on Parkersburg's south side. (Courtesy of Dr. John E. Beane.)

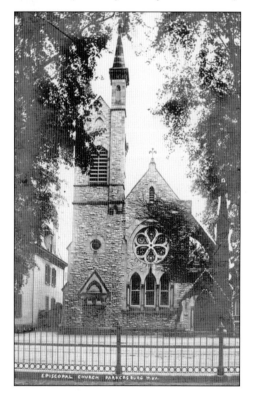

TRINITY EPISCOPAL CHURCH, C. 1907. This impressive English Gothic–style church, located at 430 Juliana Street, was erected in 1878. This structure replaced a brick church on the same site. Stone was cut from the Seventh Street Quarry owned by Sam Keenan. The church was dedicated on May 4, 1879. In 2002 and 2003, members of the Trinity Church had the sandstone exterior beautifully restored.

First Baptist Church. With the end of the Civil War, the congregation of the old Baptist Church on Ann Street was growing at a rapid rate due to an increase in the number of converts. In 1871, Deacon Lysander Dudley proposed a new brick structure based on the plans of a church he had visited in Wallingford, Connecticut. It took six years for the new building to be completed. It is located at the corner of Ninth and Market Streets. (Courtesy of Dr. John E. Beane.)

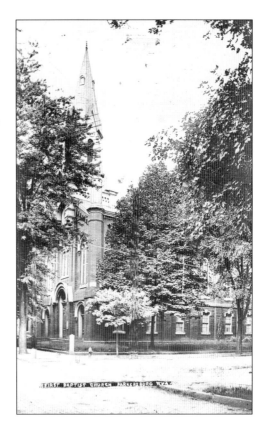

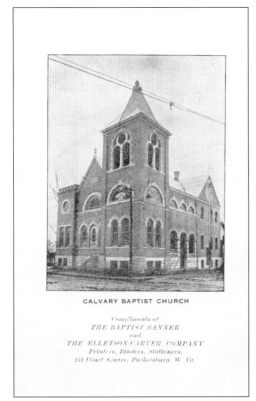

Calvary Baptist Church. Sixty-five members of the Baptist faith came together to organize the Second Baptist Church on March 6, 1901. By the time this building was dedicated in April 1903, the church was known as the Calvary Baptist Church. The congregation sold this building and merged with the Dudley Avenue Baptist Church. The combined congregations (combined in 1954) built the Emmanuel Baptist Church at 1710 Twenty-third Street in 1962. This building, located at the corner of Thirteenth and Avery Streets, is now home to Genesis Discount Framing.

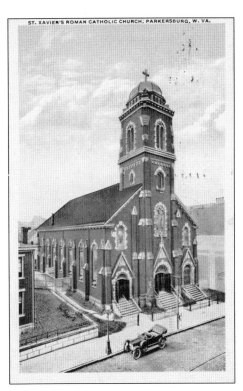

SAINT FRANCIS XAVIER ROMAN CATHOLIC CHURCH. This magnificent French Gothic structure located at 530 Market Street was completed in October of 1870 at a final cost of $85,000. P.C. Keeley was the architect and local man, Lysander Dudley, was the contractor. On June 1, 1895, a large nitroglycerine explosion occurred on a boat on the Little Kanawha River that shattered all but two of the original stained-glass windows. The windows were replaced from funds contributed by hundreds of people.

INTERIOR OF SAINT XAVIER CHURCH. Some of the most striking features of Saint Xavier's interior are the seven mural paintings by the German artist Daniel Mueller. So fine are the murals that persons from all over this country and abroad have visited the church to view them. The wooden altars were hand-carved. The inset portrait on the postcard is of the second church pastor, the Very Reverend Edward M. Hickey.

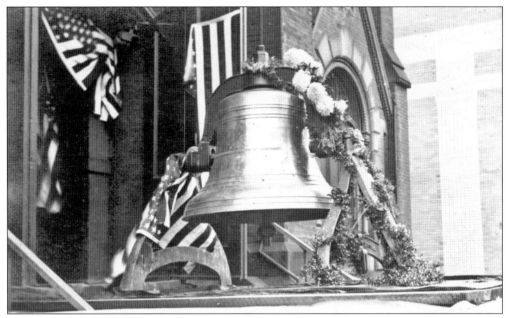

ST. CATHERINE'S BELL, SAINT XAVIER, 1915. Saint Francis Xavier Church on Market Street purchased their first and largest bell from the McShane Bell Foundry in Maryland and called it the St. Catherine's Bell. The bell, which weighs 4,000 pounds, arrived in Parkersburg in mid-November 1915. A dedication service was held November 22, when the bell was hoisted to the belfry. (Courtesy of Blennerhassett Island Historical State Park.)

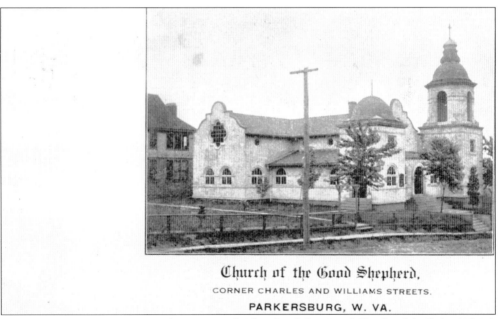

GOOD SHEPHERD CHURCH. The Memorial Church of the Good Shepherd, built in 1906, is located at the corner of Charles and Williams Streets. Inspired by the architecture of the old Spanish missions in California, the church is faced with stucco and has a red-tile roof. (Courtesy of Blennerhassett Island Historical State Park.)

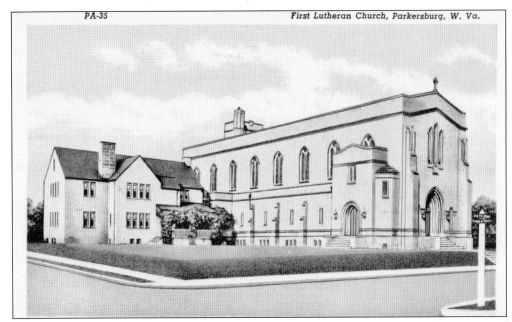

FIRST LUTHERAN CHURCH. The Lutheran faith in Parkersburg dates back to the summer of 1885. In 1905, the Lutherans had a beautiful church at 9 1/2 and Avery Streets. It was destroyed, however, by the 1909 water tank disaster. In December 1917, the congregation purchased a large lot at Nineteenth and Plum Streets. This magnificent medieval Gothic-style structure was dedicated in October 1927. The name First Lutheran Church was adopted in 1934.

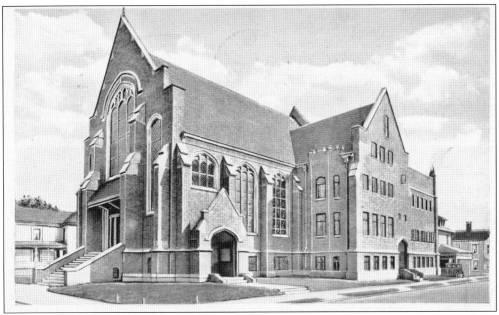

FIRST CHRISTIAN CHURCH. The Disciples of Christ were organized in Parkersburg in 1899. By the 1920s, the local congregation purchased a lot at the corner of Washington Avenue and Latrobe Street for $6,000. They hired architect Harry R. Nay to design and Plate Construction Company to construct the building. This stone-and-brick building was dedicated on September 11, 1927.

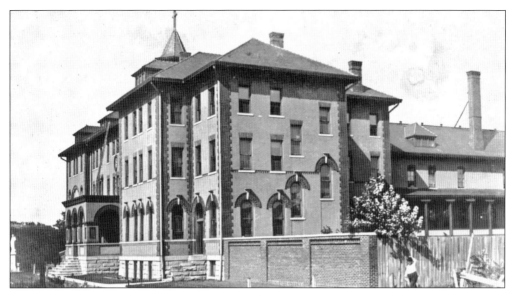

DE SALES HEIGHTS ACADEMY. This spacious brick building was constructed in 1900, as a monastery for the Sisters of Visitation (already established in Parkersburg) and, as their order decreed, as a place to teach, by providing a Catholic girls' boarding school. The new building provided ample space for the necessary classrooms and other public areas as well as private living quarters for the cloistered nuns. The boarding school was later discontinued and a Montessori academy created.

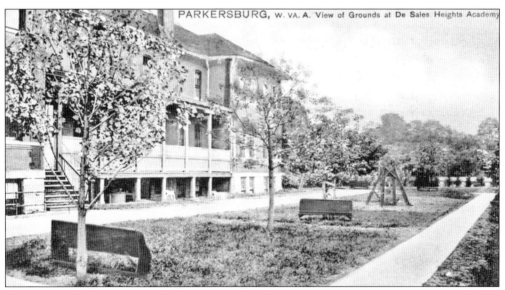

DE SALES HEIGHTS ACADEMY GROUNDS. The De Sales Heights Academy, situated on a seven-acre parcel of land on Murdoch Avenue, provided abundant grounds for the students' use. This postcard view shows the lawn on the south side of the building, which was later used as a playground for the Montessori school children. The property was also equipped with tennis and volleyball courts, a softball field, and plenty of sidewalks. Due to a declining membership and the aging population of the nuns, the academy was closed in 1992 and demolished 10 years later. (Courtesy of Blennerhassett Island Historical State Park.)

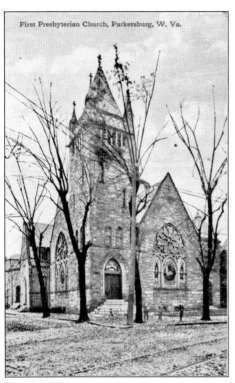

FIRST PRESBYTERIAN CHURCH. Following the 1885 merger of the First Presbyterian and Calvary Presbyterian Churches, larger quarters were needed. In December 1892, they purchased a lot on the corner of Tenth and Market Streets for a cost of $800. A new building, designed by the firm Crapsey and Brown of Cincinnati, and costing $37,000, was dedicated on July 7, 1895. The new church used theater seats arranged in a circle for the first 10 years of its existence.

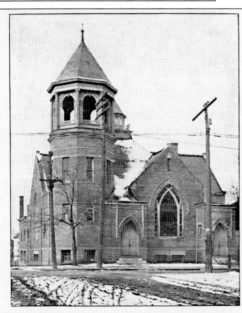

FIRST UNITED BRETHREN CHURCH. In 1863, a branch of the United Brethren of Christ was formed in Parkersburg. For many years, their church was located at Seventh and Avery Streets, but by the turn of the 20th century, they had decided to relocate "out of town." Property was secured at the corner of Sixteenth Street and St. Mary's Avenue. The building shown in this postcard was constructed for $16,000 and was dedicated on April 5, 1903. This church was replaced with a modern structure in 1966. (Courtesy of Dr. John E. Beane.)

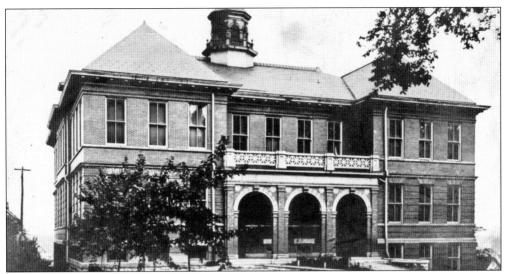

NASH/WILLARD SCHOOL, C. 1907. Construction of this 10-room brick-and-stone school, located at 1311 Ann Street, began in 1899. It was originally named after Prof. John C. Nash, a successful private schoolmaster who taught for a time at this location. For the 1903–1904 school year, the school was renamed Willard, after Miss Frances E. Willard, a leading figure in the Woman's Christian Temperance movement. In 1909, the name reverted back to Nash. The school closed at the end of the 1989–1990 school year. The building is now owned by the Mid Ohio Valley Ballet Company.

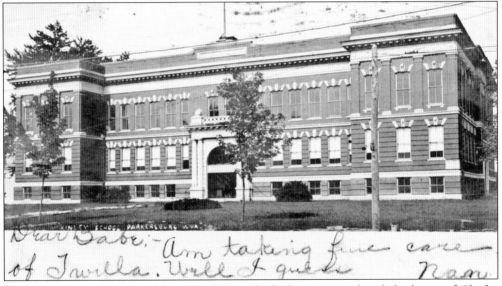

MCKINLEY SCHOOL, 1907. In 1893, the board of education purchased the home of Charles Amos Wade to establish a school in the Elberon section of Parkersburg at the corner of Nineteenth Street and St. Mary's Avenue. With the increase of people in the outer residential areas, plans to replace this two-story wood structure were established based on designs provided by architect William Howe Patton. The brick-and-stone building shown here, named for martyred president William McKinley, was opened to students in 1905. A centennial celebration is planned for McKinley School in April 2005.

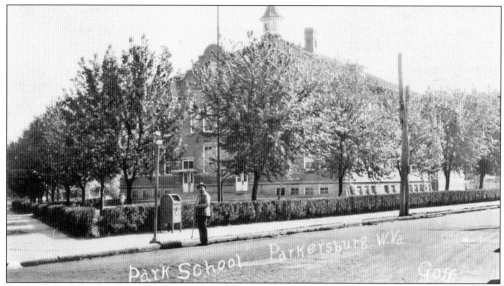

PARK SCHOOL. This 12-classroom school, located at the corner of Seventh Street and Park Avenue, was opened in 1911. Its fixtures and furnishings were state of the art. It had 20-foot-high ceilings and a bell in the rooftop tower. The gymnasium was added in 1925 and a cafeteria in the 1940s. The school was closed in July 1993 due to a countywide student consolidation plan. The building was demolished in December of 1994. A Wendy's restaurant and a CVS drug store now occupy the property.

WOOD COUNTY SCHOOLS, 1928. Three new brick-and-stone elementary schools were built for students of Wood County in 1925. These were Lincoln School (corner of Thirty-first Street and Murdoch Avenue), Neale School (corner of Twenty-third Street and Grand Central Avenue, Vienna), and Jefferson School (corner of Thirteenth and Plum Streets). This Jefferson School building later became Washington Jr. High School and is now part of the Jefferson Elementary Center Complex.

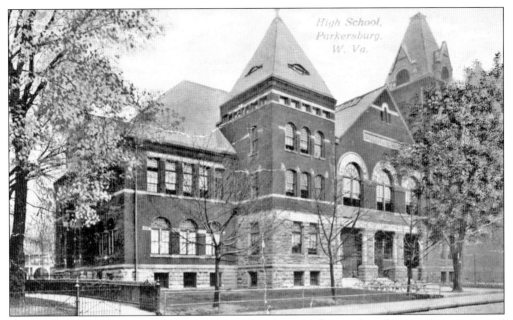

OLD HIGH SCHOOL. This building, located at the corner of Seventh and Green Streets, opened in 1891, replacing a four-room brick structure. It contained 12 classrooms as well as many special-purpose rooms. It was discontinued as a high school when the new Dudley Avenue facility was completed in 1917 and then was used as Washington Jr. High School. The building was demolished in 1964 and an Uptowner Inn was built on the site.

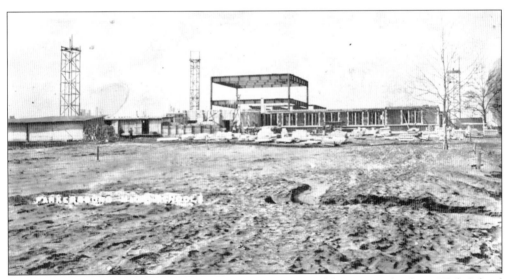

BUILDING PARKERSBURG HIGH SCHOOL. Here is a view of the new Parkersburg High School that was being built on the controversial site along Dudley Avenue. In 1914, Charles Elliott Van Devender was elected president of the board of education to oversee construction of the new school. The area he chose on the west side of Dudley Avenue was swampy and considered "out in the country." The new structure contained 38 classrooms, an auditorium, gymnasium, and many other specialized rooms. It had a capacity of 1,200 students. (Courtesy of Blennerhassett Island Historical State Park.)

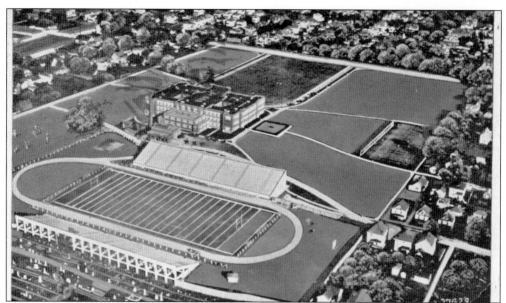

AERIAL VIEW OF PARKERSBURG HIGH SCHOOL, 1926. This is Parkersburg High School on its 27-acre campus. The stadium was completed in 1924. Each portion of the bleachers is 300 feet long. The total seating capacity is 8,000. The tennis courts were removed when the field house was built from 1950 to 1951.

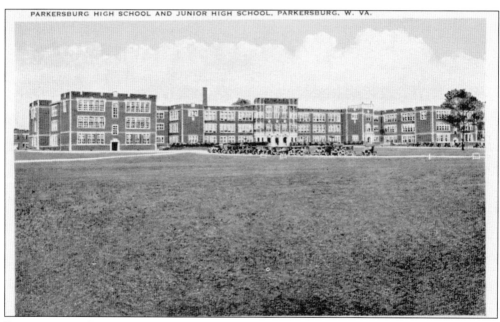

PARKERSBURG HIGH SCHOOL, C. 1930. Parkersburg High School (officially known then as Parkersburg Central Junior-Senior High School) is shown shortly after addition of the north and south wings. The wings were under construction for a year and a half. The additional classrooms required 10 new teachers. During this expansion, the cafeteria and library were also greatly enlarged. The north wing was occupied by the junior-high students and the south wing by the senior-high students.

Eight

BRIDGES, BOATS, AND STREETCARS

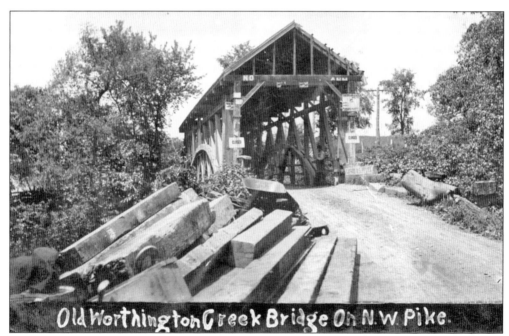

WORTHINGTON CREEK COVERED BRIDGE, 1910. This rare postcard shows the old Worthington Creek Covered Bridge being disassembled. It was built possibly as early as 1810 and appeared to have used the Burr arch truss, which was patented by Theodore Burr of New York in 1804. The bridge, part of the Northwestern Turnpike, spanned Worthington Creek. Advertisements posted along the front of the bridge included ones for the Moss Bookstore, Woodward Mfg. Co., and a sign for Red Bird Coffee. The bridge was closed on May 25, 1910, and was soon replaced with a concrete structure.

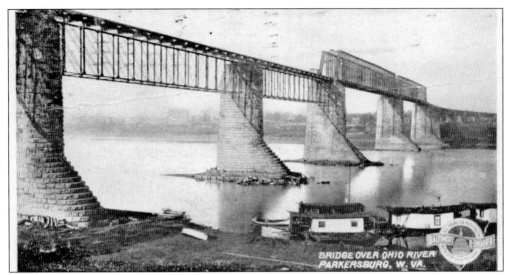

BALTIMORE & OHIO RAILROAD BRIDGE. Construction of the Baltimore & Ohio Railroad Bridge across the Ohio River from Parkersburg, West Virginia, to Belpre, Ohio, began in May 1869, and was completed January 7, 1871. Prior to its existence, westbound trains had to be transported a few cars at a time across the river by ferry. The bridge required 53 sandstone piers. The framework consisted of wrought iron. There were two adaptations of the Whipple truss and several inverted trusses within the six river spans, each ranging from 209 to 349 feet. At nearly a mile long, it was the longest railroad bridge in the world. This view of the bridge is taken from the West Virginia side.

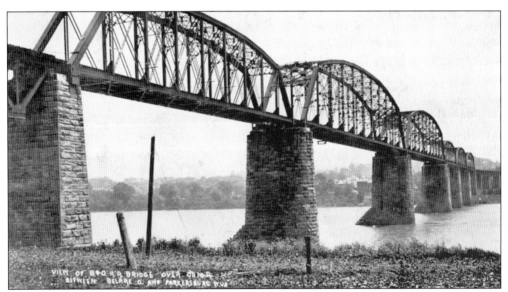

BALTIMORE & OHIO RAILROAD BRIDGE, REBUILT. The construction of the Baltimore & Ohio Railroad Bridge at Parkersburg was partially financed by John W. Garrett, a wealthy philanthropist from Baltimore and president of the Baltimore & Ohio Railroad. In 1904, Garrett's stocks were purchased by the Baltimore & Ohio Company, and shortly thereafter this bridge's framework was completely rebuilt using steel. In 1929, it was strengthened again to carry more tonnage. This view, taken from the Ohio side, shows the framework as it looks today.

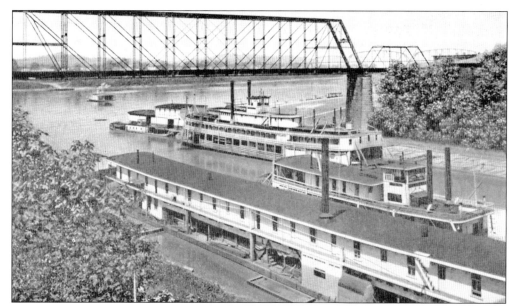

OHIO RIVER RAILROAD BRIDGE. The 300-foot-long Ohio River Railroad Bridge across the Little Kanawha River brought passengers to and from the Ann Street Railroad Station. This iron bridge with sandstone piers was built in 1883. By the 1920s, the bridge was deemed unsafe, and a half-million-dollar renovation was planned. In 1924, the Vang Construction Company reinforced the sandstone piers with concrete, and the Fort Pitt Bridge Works replaced the old iron framework with steel. The bridge is still used.

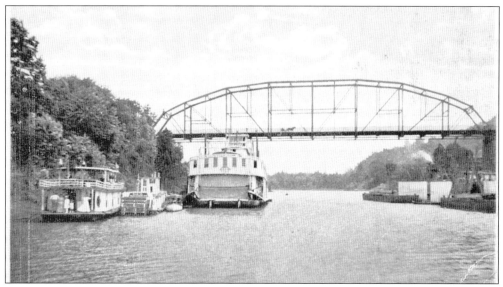

JULIANA STREET BRIDGE. In the 1880s, a person crossing the Little Kanawha River used a covered bridge located at the end of Market Street. The Market Street Bridge was destroyed by a logjam on July 10, 1888. A squabble ensued between merchants of Market and Juliana Streets over where a replacement bridge should be constructed; both streets' merchants wanted to lure customers to their shops. The Juliana Street merchants won out, and the new bridge, shown above, was constructed at the foot of Juliana Street in 1891.

JULIANA STREET BRIDGE. Here, an unknown group poses on the Juliana Street Bridge c. 1908. This bridge served Parkersburg until 1961, when it was condemned. A replacement bridge, which is currently still in service, was opened in the fall of 1971.

PARKERSBURG-BELPRE BRIDGE CONSTRUCTION, C. 1915. In 1912, the Parkersburg-Ohio Bridge Company was chartered to construct and operate a bridge across the Ohio River, connecting Parkersburg to Belpre. Prior to this, citizens relied on ferry service to cross the Ohio River. A German bridge designer, Hermann Lamb, was hired to plan the new bridge. This postcard shows unidentified workers finishing the deck for the bridge. (Courtesy of Blennerhassett Island Historical State Park.)

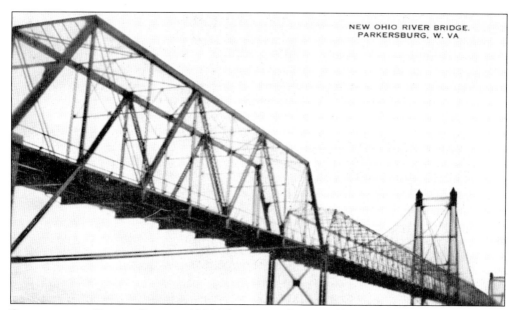

PARKERSBURG–BELPRE BRIDGE, 1916. The new steel-wire-cable suspension bridge was opened in 1916. Opening as a toll bridge, it consisted of four spans of 800 feet, 300 feet, 400 feet, and 200 feet, respectively. The roadway was 25 feet wide, with a 5-foot sidewalk. By the 1930s, enough money had been collected to pay for the cost of the bridge, and the toll was lifted. In June 1937, the State of West Virginia purchased the bridge for $1,088,000.

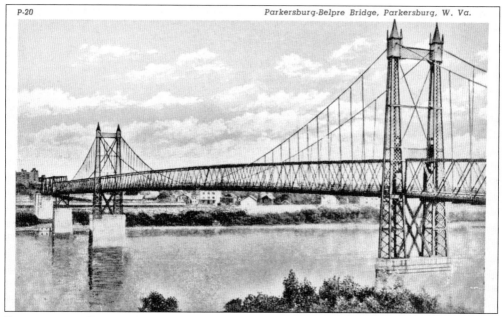

PARKERSBURG–BELPRE BRIDGE. By the 1970s, plans were begun to replace the aging structure. A new bridge, built between the railroad bridge and this bridge, was dedicated on October 16, 1979. The old Parkersburg-Belpre Bridge, shown here, was demolished by explosives on March 16, 1980. Citizens recall the narrow passageway of the old bridge and the unforgettable humming sound it made when driving across it.

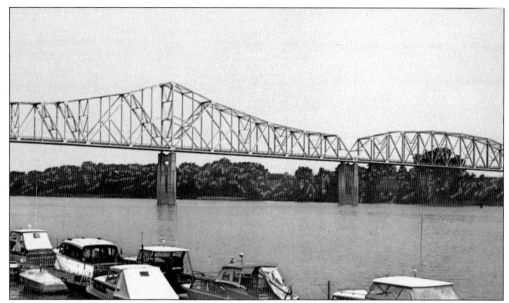

PARKERSBURG MEMORIAL BRIDGE, 1954. Dedicated on January 12, 1954, to "all veterans of all wars," the Memorial Bridge spans the Ohio River between Parkersburg, West Virginia, and Belpre, Ohio. Costing $6.5 million, the bridge opened with a ribbon-cutting ceremony by Col. C.E. Morrison, the oldest veteran in the area. An estimated 1,000 people were on hand for the event. This too was a toll bridge, and in 1954, it cost 15¢ for an automobile to cross. Within the first six hours of the opening, nearly 2,200 vehicles had made the passage across.

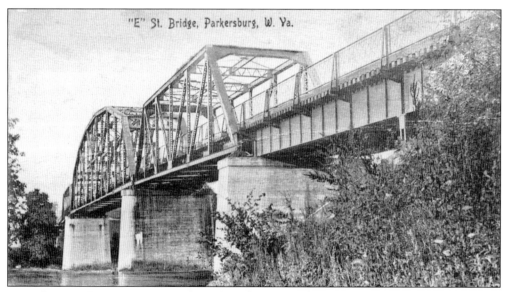

EAST STREET BRIDGE. In 1906, Shattuck Park was being constructed in south Parkersburg. To service the new park, a bridge was planned for the Little Kanawha River at East Street. A design was created by Ralph Modjeski, and the Brady Construction Company hired 150 Hungarian laborers to begin building the piers. It required approximately one year to complete the 800-foot-long steel-truss bridge. The bridge opened on May 21, 1908, just in time for the state fair at Shattuck Park. This span has since been replaced.

BOATING ON THE LITTLE KANAWHA RIVER, 1906. A leisurely boating trip on the Little Kanawha River is captured in this real photo postcard. Along the sandstone bridge pier of the Ohio River Railroad Bridge is the Pope Dry Docks. Owned by Ed Pope, this enterprise built and repaired steamboats.

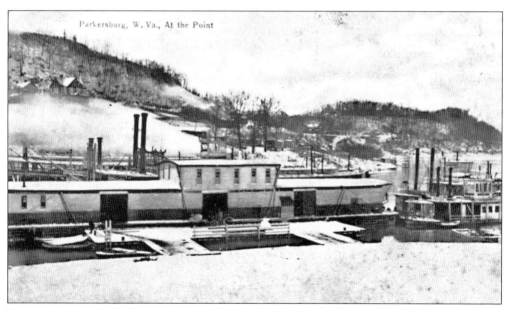

THE POINT, C. 1909. The point formed by the junction of the Ohio and Little Kanawha Rivers was one of the busiest places in town. In the center is the Parkersburg Wharf Boat, a "floating warehouse" that temporarily held freight that was being moved to and from steamboats. The wharf boat was built in 1882 in Murrysville, West Virginia, by Captain Good. The 165-foot craft was very profitable in its early years, but by the 1930s, times were becoming hard for boat owners. In the winter of 1935 and 1936, heavy ice damaged the hull, and the wharf boat was scrapped in March 1936.

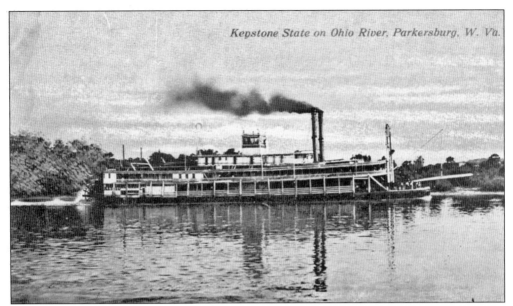

KEYSTONE STATE STERNWHEEL PACKET, C. 1908. The *Keystone State*, shown here in Parkersburg, was built at the Knox Yard in Harmar, Ohio, in 1890. In October 1909, she was sold and taken to Point Pleasant to receive a new hull. The new owner, Levi Sparr, did not meet all of his financial obligations, and the boat remained in litigation for years. After changing ownership several more times, in 1913 she was purchased again, converted into an excursion boat, and renamed the *Majestic*.

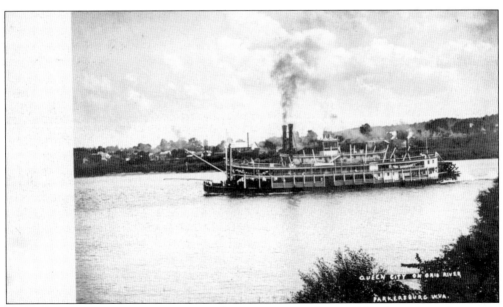

QUEEN CITY STERNWHEEL PACKET. Built in Cincinnati, Ohio, in 1897, the steamer *Queen City* was created to transport passengers in a stylish manner. She had mahogany cabins embellished with gilt trim and pressed-tin ceilings. Patrons were greeted by mahogany glass-paneled stateroom doors. The boat struggled financially in the 1920s and 1930s. It eventually became a wharf boat at Pittsburgh and sank in January 1940.

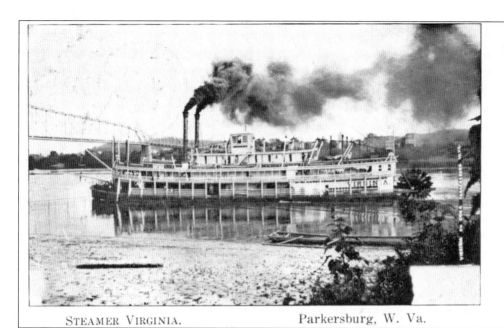

STEAMER VIRGINIA. Parkersburg, W. Va.

VIRGINIA STERNWHEEL PACKET. The steamer *Virginia* is shown here at Parkersburg heading down the Ohio River. The boat was built in 1895 by the Cincinnati Marine Railway and was 235 feet in length. It is best known as the boat that was stranded in Williamson's cornfield in March 1910 at Willow Grove, West Virginia. This incident has been the topic of many articles and books. The steamboat was rebuilt in 1911 and renamed *Steel City*.

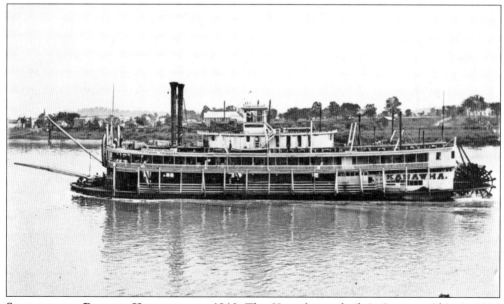

STERNWHEEL PACKET *KANAWHA*, C. 1910. The *Kanawha* was built in Ironton, Ohio, in 1896 by the Bay Line for the Pittsburgh-Charleston trade. In mid-summer 1911, the Rivers & Harbors Committee rode her from Pittsburgh to Cairo, Illinois, during a time when the river was so low that no other regular packets could navigate the Ohio. The steamboat met its fate on a wintry night in 1916. Wreckage of the boat is pictured in the Disasters section of this book.

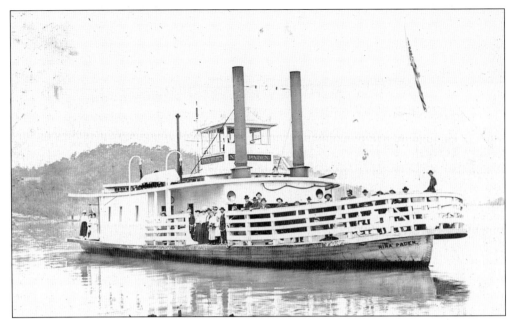

PARKERSBURG-BELPRE FERRY. In 1896, J. Henry Shaw of Belpre, Ohio, commissioned a boat builder in Marietta, Ohio, to construct a ferryboat for use between Parkersburg, West Virginia, and Belpre, Ohio. This 103-foot-long boat had a recessed side wheel and was named *Nina Paden*. The ferry was continually in use until February 1917, when the boat was sold to Ashland, Kentucky. (Courtesy of Dr. John E. Beane.)

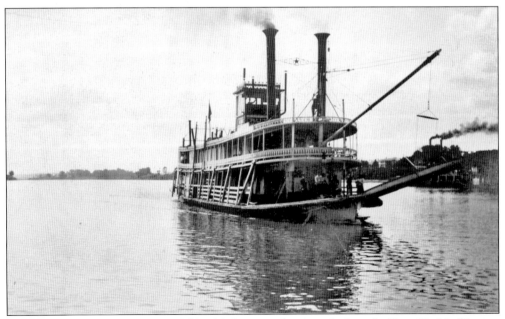

STERNWHEELER *RUTH*, C. 1916. This 136-foot steamboat was built at the Knox Yard in Harmar, Ohio, in 1893. She had several routes on the Ohio but ended up running the Parkersburg to Pittsburgh trade route in 1916. In 1918, the boat was destroyed because of ice at the Ohio River Dam #13.

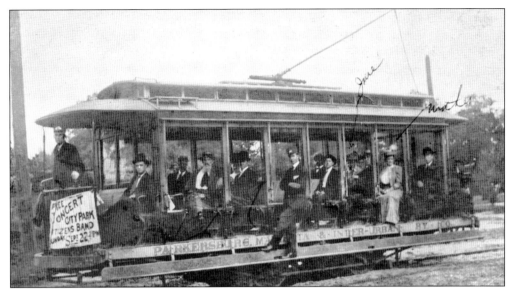

PARKERSBURG STREETCAR, 1907. Parkersburg's streetcar system was incorporated in 1888. By 1898, it had two basic lines: the Inner Loop designated by green cars, and the Outer Loop designated by red cars. In 1902, Parkersburg, Marietta, and the interurban lines merged, forming the Parkersburg, Marietta and Inter-Urban Railway Company. Shown here is a ten-bench, open streetcar. In 1923, the Parkersburg/Marietta, Fairmont/Clarksburg, and Morgantown companies all merged under the name Monongahela–West Penn Public Service Company.

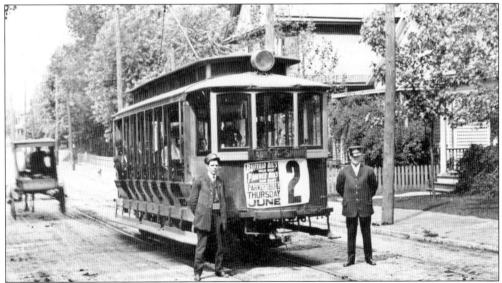

MARKET AND SPRING STREET TROLLEY. Guy De Vaughn, streetcar operator (on the right), and an unidentified man are standing beside the Market and Spring Streets inner loop trolley, part of the Parkersburg and Marietta Inter-Urban Railway. The poster on the front of the trolley is advertising the Buffalo Bill's Wild West and Pawnee Bill's Great Far East Show to be held at the Seventh Street Show Ground (also known as Stephenson's Field) on Thursday, June 2, 1910. The 1910 season was the farewell performance for great Wild West showman William F. Cody. (Courtesy of Blennerhassett Island Historical State Park.)

TRANSPORTING COAL, C. 1906. This real photo postcard view, taken from the bank of the Ohio River, shows two paddlewheel towboats pushing coal barges on the river. Transportation by river barge was the most cost effective way to move bulky cargo such as coal. A system of towing is still used today to transport coal and other industrial needs up and down the navigable rivers. (Courtesy of Blennerhassett Island Historical State Park.)